The
Commons
of the
Mind

THE PAUL CARUS LECTURES

PUBLISHED IN MEMORY OF

PAUL CARUS
1852–1919

EDITOR OF
THE OPEN COURT
AND
THE MONIST
FROM
1888 TO 1919

Postures of the Mind: Essays on Mind and Morals
A Progress of Sentiments: Reflections on Hume's Treatise
Moral Predjudices: Essays on Ethics

THE PAUL CARUS LECTURE SERIES 19

The Commons of the Mind

Annette C. Baier

OPEN COURT

Chicago and La Salle, Illinois

Open Court Publishing Company is a division of Carus Publishing Company.

Copyright © 1997 by Carus Publishing Company

First printing 1997

Library of Congress Cataloging-in-Publication Data
Baier, Annette.
 The commons of the mind / Annette C. Baier.
 p. cm.—(Paul Carus lectures : 19th ser.)
 Lectures given at the 92nd meeting of the Eastern Division of the
American Philosophical Association, December 28-30, 1995.
 Includes bibliographical references and index.
 ISBN 0-8126-9349-3 (cloth : alk. paper).—ISBN 0-8126-9350-7
(pbk. : alk. paper)
 1. Knowledge, Sociology of. 2. Reasoning. 3. Intention.
4. Ethics. I. American Philosophical Association. Eastern
Division. II. Title. III. Series.
BD175.B33 1997
128'.33—dc21
 97-113
 CIP

Contents

Preface

I have left these lectures more or less as they were given at the 92nd meeting of the Eastern Division of the American Philosophical Association, December 28, 29, 30, 1995, adding only footnotes, sometimes lengthy ones, and an appendix to each of the three lectures.

My debts will, I hope, be fairly obvious. I have learned from my teachers, my students, my colleagues, those with whom I have shared platforms at conferences, from philosophical correspondents, and from my distinguished predecessors in this series. My most faithful critic and discussant has for nearly forty years been Kurt Baier, my most recent predecessor as Carus Lecturer. I have learned much from those (the majority of my Pittsburgh colleagues) who accept some version of the sort of social constructionist view of reason, responsibility, and morality which is defended in these lectures, and much also from those who challenge it.

Special thanks are due to Sergio Tenenbaum, who did his best to curb my proven tendency to anti-Kantian excesses, to Jennifer Nagel, who pointed out obscurities in an early draft of these lectures, and to Collie Henderson, who prepared the manuscript with her customary patience and expertise. These lectures are not just about our shared mental powers, they are also their product.

Lecture I:
Reason

In these lectures I shall look at three of the activities we take to be quintessentially mental ones: reasoning, intending, and moral reflection. In each case I will be concerned with the extent to which we all, as minded beings, share in what John Locke called "one Community of Nature," and with whether this mind community can be understood merely as a matter of our "being furnished with like Faculties,"[1] or whether a closer "community" is involved. Locke wrote "God, that hath given the World to Men in common, hath also given them Reason to make use of it to the best Advantage of Life,"[2] and I shall be asking whether reason, and other aspects of mind, are also possessed "in common," in Locke's strong sense in this passage. I shall be concerned with the commons of the mind.[3]

1. John Locke, *Second Treatise on Government*, sec. 5.
2. John Locke, *Second Treatise on Government*, sec. 26.
3. I do not take "mind" to be something to be contrasted with "nature" or with "world," as if minds and their commons were not part of nature and of the world, were somehow supernatural or otherworldly, spectators not participants in nature and the world. Nor do I take mind to be essentially "inner" and private, in contrast to what is out there in the public world. Our expressed reasonings and our intentional actions are publicly accessible, yet just as mind exhibiting as our private daydreams and secret motives. Arthur Collins, in *The Nature of Mental Things* (Notre Dame, Ind.: University of Notre Dame Press, 1987), has argued persuasively against the notion that the realm of the mental is that of "inner states," but the view lingers on. It is found, for example, in Michael Bratman's claim "We use the concept of intention to characterize both our actions and our minds. You believe (correctly) that I have *intentionally* written this sentence. . . . Perhaps you also believe that when I wrote it last January I *intended* to discuss it in the symposium in March. In the former case you use the concept of intention to characterize my action; in the latter case you use the concept to characterize my mind." ("What is Intention?" in *Intentions in Communication*, ed. Philip R. Cohen, Jerry Morgan, and Martha E. Pollack [Cambridge, Mass.: MIT Press, 1990], p. 15.) The implication is that my "prior intentions" are "in" my mind in a way that my intentions-in-acting are not. Bratman had drawn the same sort of distinction in his book *Intention, Plans, and Practical Reason* (Cambridge, Mass.: Harvard University Press, 1987). See for example p. 3: "our commonsense psychological scheme admits of intentions as states of mind, and it also allows us to characterise actions as done intentionally, or with a certain intention."

Descartes in his *Discourse on the Method of Rightly Conduct-ing One's Reason* writes "As regards reason or sense, since it is the only thing that makes us men and distinguishes us from the beasts, I like to believe that it exists whole and complete in each of us" (*AT*, 6:2).[4] Since Descartes, it has seemed natural for philosophers to take reason to be complete in each individual human reasoner. Yet if, like Descartes, one begins with the con-viction that, since one can find oneself rejecting what one has been taught, and reasoning in solitude, reason is complete in one, then one almost inevitably faces skeptical problems when asked for one's grounds for believing that there really are any other reasoners besides oneself. Descartes's own suggested tests, of appropriate verbal response and versatile intelligent problem solving,[5] are notoriously unconnected, or unconnected by him, with what they are supposed to test for—the presence of a sequence of conscious self-critical thoughts, reason as he manifested it to himself in, say, the *Second Meditation*. There, having as the outcome of his skeptical arguments decided to proceed as if there were "no sky, no earth, no minds, no bod-ies," he famously finds that he cannot suppose that he himself, as a doubter and so a thinker, does not exist. Having reasoned his way to this self-certainty, he makes the interesting claim that the terms he now uses to characterize himself, *mens, animus, intellectus, ratio,* are terms whose meaning was previously unknown to him. This, I take it, is partly because, in his earlier precritical uses of them, he had taken them to be what the Aris-totelians who taught him had taken them to be, possessions that a human being could have only in as far as it had sense organs, since nothing could be in intellect if not first in sense, so that one who still doubted his body's existence would not be

4. The abbreviation stands for C. Adam and P. Tannery, eds., *Oeuvres de Descartes,* 12 vols. (Cerf 1897–1913; reprinted Paris: J. Vrin, 1957 and 1986), vol. 5, p. 2. Future references to Descartes will be given in a similar manner. Translations are those of John Cottingham, Robert Stoothoff, and Dugald Murdoch, as given in *The Philosophical Writings of Descartes,* vols. 1 and 2 (Cambridge University Press, 1985), sometimes slightly altered, as in the above, where Stoothoff has "I am inclined to believe" for the French "je veux croire."

5. Descartes, *Discourse,* pt. 5; *AT,* 6: 56–59.

sure of his mind, intellect, or reason. But it is also because, on the story the meditator tells about himself, he has only in the last two days really used his critical reason, as distinct from his ability to take beliefs on trust from various unexamined sources. If reason is the ability to think in the way that Descartes's meditator did in the *First* and *Second Meditations,* then one does not know for sure that one has such a reason until one finds oneself reasoning in such a manner, that is until one demonstrates reasoning, in the sense of "gives a demonstration of" it.

One would not know for sure that anyone else had reason, unless one found them reasoning in a similar fashion, seeing reasons for doubt, reasons for restricting the doubt, reasons for drawing out new conclusions from any certainties already established. On the face of it, there should be no problem in getting such assurance—if when one sends one's manuscript off to one's friend, Mersenne, whom one has, in one's precritical phase, taken to be a reasoner, one gets back several sets of objections, exhibiting different styles of thinking, and finds most of those objections worth replying to, one would seem to have sufficient grounds to be sure that there are at least as many other reasoners as there are authors of the intelligible and appropriate *Objections.* And the face of it is surely not a false face. But if it is as easy as that to establish the existence of reasoners, then Descartes could have assured himself of his own existence as a reasoner simply by conversing with Mersenne, or any other friend.[6] He did not need to find "a serene retreat in peaceful solitude," to "converse with myself alone." And it is striking that, even given that he *did* make that solitary retreat and think that his reason manifested itself then more strikingly than in any of his previous intellectual ventures, such as his mathematical investigations, he almost immediately populates his solitude. He invents an imaginary adversary for himself, a clever deceitful demon, someone against whom to match his

6. See my "How to Get to Know One's Own Mind: Some Simple Ways," in *Philosophy in Mind: The Place of Philosophy in the Study of Mind,* ed. Michaelis Michael and John O'Leary-Hawthorne, *Philosophical Studies Series* 60 (Dordrecht: Kluwer Academic Publishers, 1994), pp. 65–82.

wits. And even in doing this, he employs more than one voice—
the doubting voice, and the more confident voice of the suc-
cessful certainty-attainer, so that the style of the thinking in the
Meditations is itself a kind of "objections and replies," all
enacted in one meditator. The meditator has to become his
own objector and commentator, as anyone must, if she resolves
to "converse with herself alone," yet expects the conversation to
count as a search for truth. So the reason that he finds complete
in himself, in his solitary retreat, is a sort of microcosm of the
reason that exhibited itself, later, in the objections his corre-
spondents made to his writings, and in his replies to them.

Should we take reason to be complete in each individual,
but also incipiently social, easily able to adapt itself to actual
social interchanges, and capable, in advance, of imagining such
exchanges? Or should we take it to be essentially a social skill,
but one that can adapt itself to temporary solitude, by turning
its monologues into pretend dialogues or pretend many-personed
discussions?

Despite his recognition that thinking is conversing,
Descartes notoriously took the former view, and showed a strik-
ing lack of any sense of indebtedness to those (parents, nurses,
educators) with whom he had initially matched his wits, and
honed his powers of reasoning. In the *Third Meditation* he dis-
misses the suggestion that his existence as a thinker might
depend, or have depended, upon the parents who engendered
him. And as for his early partners in conversation, the nurse-
maids appointed by his father and grandfather to care for him,
they merely fed him the beliefs that his reason later rejected.
Nor did his school teachers, including his philosophy teachers,
do very much better. Their role was mainly negative—to pro-
duce in him the felt need to "set aside all the opinions I had
previously accepted and start again, from the beginning." Still,
it is striking that when he does attempt this new start, he does it
by imagining powerful deceiving influences from whom he
must guard himself, by voicing objections to his own tentative
conclusions, and by reeducating himself, in the sense of bring-
ing himself along, step by step, by instructive questions and

replies, even by occasional playtimes or recreations, when he lets his vagabond mind wander off for a little, before recalling it to its vocation of disciplined thinking in its search for truth.

How are we to decide whether to take reason to be an essentially private thing that can, however, turn on a public display when it chooses to do so, or, like conversing, to be an essentially social skill, which can, however, be retained a while through periods of solitary confinement? Is this an empirical matter, to be decided by looking to see if reasoning power atrophies in long solitary confinement, or fails to develop in children deprived of normal human company? Or might we decide the question without inhumane experiments by looking to see how those of us who experience the normal mix of sociality and solitude treat such stretches of thinking as purport to be reasoning? When are we confident that some such stretch, of which we take ourself to be more-or-less sole author, really is a piece of reasoning? Usually only when some other reasoner can follow it, and reassure us that commonly accepted standards of reasoning are minimally met.[7] Do we feel the need to *apologize* for multiple authorship, as if that might be a prima facie count against the coherence of a multiply authored piece of reasoning? Descartes would think we should. He writes, in his *Discourse on the Method of Rightly Conducting the Reason,* that he was frequently struck by the realization that "there is not usually so much perfection in works composed of several parts and produced by various different craftsmen as in the works of one man."[8] Cities planned by one city planner are "better arranged" than those that have grown slowly, with many builders contributing to the end result. "Crooked and irregular" streets typify those ancient towns that lacked one guiding planning mind. As in architecture, so also in legal systems—better, he thinks, to

7. I called this feature of our reason "heteronomy" when I first drew attention to it in "Mind and Change of Mind," a lecture given at the Chapel Hill Philosophy Colloquium, October 1977, published in *Midwest Studies in Philosophy, Metaphysics* 4 (1979), republished in *Postures of the Mind* (Minneapolis, Minn.: University of Minnesota Press, 1985). I there took this social account of thinking to have been endorsed by Wittgenstein, and also by Wilfrid Sellars. I elaborated such a view in "Cartesian Persons," *Philosophia* 10, nos. 3–4 (1981), reprinted in *Postures of the Mind.*

8. Descartes, *Discourse,* pt. 2; *AT,* 6:11.

have Sparta's laws, which may have been "contrary to good morals," but at least had the coherence of purpose which is to be expected only if the laws stem from one legislator, than to have a slowly accumulated collection of laws dating from different periods. And in a system of beliefs, especially one pretending to the title of a science, it is, Descartes writes, even more essential to have the shaping guidance of one "man of good sense" than "the opinions of many different persons," accumulating little by little.

This prejudice in favor of one person's unprejudiced reasoning over the product of many reasoner's combined efforts was a healthy attitude in an authoritarian culture, and none of us really regret Descartes's determination to go it alone. But if we ask not just what view was a salutory corrective in a society that demanded conformity to traditional dogmas, but ask rather what is in fact the nature of our truth-seeking and truth-recognizing capacity, then other less individualist conceptions of reason have a claim to a hearing. For we need not be authoritarians, simply because we are skeptical of the single and solitary thinker's chances of recognizing truth should she find it, or of displaying any capacity which can proudly be advanced as that which obviously displays our human difference from, and superiority to, the other living things with whom we find ourselves sharing a planet, let alone of "stripping off outward forms" and getting at the naked truth.

As Descartes was well aware, one obvious difference between human and nonhuman beings is that we human beings converse, and when sufficiently motivated can get to understand and speak each other's native languages. Descartes promotes this linguistic capacity to the status of a *sign*, to a reason-possessing being, of the presence of another reason-possessing being. Yet he does not tell us why this linguistic capacity is a reliable indicator of the presence of reason. As Hobbes[9] and Berkeley[10] emphasized, the possession of a shared language

9. Thomas Hobbes, *Leviathan*, chap. 4, third and fourth paragraphs.
10. George Berkeley, introduction to *A Treatise Concerning the Principles of Human Knowledge*, sec. 20.

enables us to become bullies and bullied, indoctrinators and indoctrinated, entertainers and entertained, insulters and insulted, as well as communicators of reasoning and evaluators of each other's reasonings. So it is understandable that Descartes, intent as he was on distinguishing the light of reason from the darkness of inherited master-doctrines, would not want simply to equate the possession of reason with membership in a language community. For the term "reason" is an honorific title, reserved, in Locke's words, for "that faculty whereby man is supposed to be distinguished from the brutes."[11] Dugald Stewart agrees with Locke when in the early nineteenth century Stewart surveyed varying conceptions of "reason," ranging from broad ones that included the ability to distinguish right from wrong and to combine suitable means to ends in addition to discursive or inferential ability, to narrower ones, such as that which Hume adopts in the *Treatise,* which restricted reason to inference. The one shared element in all the conceptions he surveyed, he writes, is that reason includes "those principles, whatever they are, by which man is distinguished from the brutes."[12] Depending on what mental distinguishing marks we choose to pride ourselves on, the term "reason" will shift in its sense and in its scope. "Reason" is a title, reserved for what distinguishes the chosen species from all oth-

11. John Locke, *Essay Concerning Human Understanding,* bk. 4, chap. 17, sec. 1. Locke, while taking it that reason does make us superior to the beasts, was marvelously open-minded about just who the relevant "we" are, and most suspicious of what we would call speciesism, indeed of the very notion of a natural species. Nor did he think that, among the thinking creation, we were anything but inferior. Our faculties, he writes, are "dull and weak," doubtless well enough fitted to "knowledge of our Duty" and "our Business in this World," business for which it is more important that we be able to read the clockface than be able to see into the "secret contrivance" of its works, or into the structure of the matter composing its parts. Man "in all probability is one of the lowest of all intellectual beings" (*Essay,* bk. 4, chap. 3, sec. 23), and higher such beings (with other duties?) well may understand a lot more about the physical universe than we do. Locke speculates about such superior knowers being able to "assume to themselves Bodies of different Bulk, Figure, and Conformation of Parts . . . and shape to themselves Organs of Sensation and Perception, as to suit them to their present Design" (*Essay,* bk. 2, chap. 23, sec. 13), altering their eyes' focus, depth of field, degree of magnification at will. And he doubts not that "the infinite Power and Reason of God may frame Creatures with a thousand other Faculties and ways of perceiving things without [outside] them, than what we have" (Ibid.).

12. Dugald Stewart, *The Elements of the Philosophy of the Human Mind* (New York: James Eastman and Co., 1948), p. 4.

ers. The term refers, in Kant's words, to what has a "stately guise and established standing."[13] As we become aware of the existence of languages, of a sort, in species such as dolphins, whales, and song birds, we will be less inclined to take any display of linguistic prowess to indicate the possession of reason, more inclined to restrict the linguistic expressions of reason to those that link with the problem-solving ability which was Descartes's second proposed test. Only such speech as seems to be employed to state and try to solve some epistemic problem, not just to greet, to express emotion, to communicate simple information, to attract a mate, to soothe an infant, to warn a competitor, to chide an offender, gets counted as the sort of speech that expresses reason.

Dugald Stewart self-consciously avails himself of this tendency to equate reason with whatever it is that enables us to engage in one particular estimable activity, namely reason*ing,* where this is taken to be inference, either deduction or else some such "logical process" essentially connected with "the discovery of truth, or the attainment of the objects of our pursuit," and is taken not to include memory, perception, imagination, fancy, and wit, even though some of these (memory and perception) are closely connected with the discovery and retention of truth. Locke had adopted this usage, equating the reason that distinguishes us from the brutes with the "sagacity" to find and the "illation" to rightly order ideas that enable us the better to discern truth, seen as a matter of the agreement and disagreement of ideas. Locke takes it that this distinguishing faculty is not sense perception (since our senses are far from being noticeably superior), nor even "reflection" or "internal sense," but rather the ability to connect and order such ideas as our senses make available to us. Reason is what "enlarges" our knowledge and "regulates" our assent. Locke takes it to cover probability estimation as well as "proof" and "demonstration,"

13. Immanuel Kant, *Critique of Pure Reason,* A710, B738. Kant is in the passage emphasizing what he sees as the essentially *disciplinary* (and self-disciplinary) character of reason. "That reason, whose proper duty it is to prescribe a discipline for all other endeavours should itself stand in need of such discipline may indeed seem strange."

and so takes it to cover all "discursive" thought in which some already assented to ideas lead us to other ideas, and serve as warrants for giving assent to them. "Reason," in effect, comes to stand for our inferential faculty or faculties, seen to be what gives us superiority over other living things.

Perhaps in reaction against this decision of his tutor, Locke, to confer the title "reason" exclusively on our inferential capacities, Anthony Ashley Cooper, Third Earl of Shaftesbury, in his *Essay on the Freedom of Wit and Humour,* takes a broader view. He tells us "That according to the Notion I have of *Reason,* neither the written Treatises of the Learned, nor the set discourses of the Eloquent, are able of themselves to teach the use of it. 'Tis the Habit alone of Reasoning, which can make a Reasoner. And men can never be better invited to the Habit, than when they find Pleasure in it. A Freedom of Raillery, a Liberty in decent Language to question every thing, and an Allowance of unravelling or refuting any Argument, without offence to the Arguer, are the only Terms which can render such Speculative Conversations any way agreeable. For to say truth, they have been render'd burdensom to Mankind by the Strictness of the Laws prescrib'd to 'em, and by the prevailing Pedantry and Bigotry of those who reign in 'em, and assume themselves to be Dictators in these Provinces."[14] Shaftesbury keeps the Lockean assumption that reason is what enables us to engage in reason*ing,* but extends the range of what counts as reasoning. Where Locke contented himself with freeing reasoning from the strict rules of the syllogism, but left it still within the confines of serious argument and inference, Shaftesbury opens its borders to let in wit and gentlemanly raillery. He takes it for granted that the habit of reasoning is a habit of conversing—the only issue in dispute is whether the conversation must be solemn, grave, and deferential to some set of strict rules, or can be diverting, mocking, free and sometimes disrespectful of received views. The diverting conversation Shaftesbury is here in the process of

14. Third Earl of Shaftesbury (Anthony Ashley Cooper), *Characteristics of Men, Manners, Opinions, Times,* vol. 1, *Sensus Communis, an Essay on the Freedom of Wit and Humour,* sec. 4.

reporting, as an exemplar of his notion of true reasoning, concerned morality and religion, and ended in inconclusiveness and laughter. "The Humour was agreeable, and the pleasant Confusion in which the Conversation ended is at this time as pleasant to me on Reflection; when I consider that instead of being discourag'd from returning to the Debate, we were so much the readier to meet again at any time, and dispute upon the same Subjects, even with more Ease and Satisfaction than before."[15] Shaftesbury even cites biblical example, in God's dealing with Jonah, to establish the place of teasing, wit, and humor in the dealings of reasonable persons. So reason, on his version of it, is the capacity for all sorts of conversations, in the spoken and the written word. As he blesses "The Soul of that Charitable and Courteous Author, who for the common Benefit of his Fellow-Authors introduced the ingenious way of *Miscellaneous* Writing!"[16] so he stretches the Lockean concept of reason to include a great miscellany of forms of conversational reflection—soliloquy, dialogue, treatise, letter, essay, philosophical rhapsody, and, of course, miscellanies.[17] Few of us professional philosophers today would dare try chapter summaries as wide ranging as Shaftesbury's. Chapter 2 of *Miscellany* 1 is summarized thus: "Of Controversial Writings: Answers: Replys—Polemick divinity; or the Writing Church-Militant;—Philosophers, and Bear-Garden.—Author's pair'd and match'd;—the Match-makers.—Foot-Ball.—a Dialogue between our Author and his Bookseller." And the contents live up to this preview. The sequence of reflections in such a chapter is not what we would give a beginning student as an easy sample of inference, yet no reasonable reader has trouble following Shaftesbury's train of thought, nor of seeing the relevance of bear gardens to the sort of philosophical debate that he claims delights booksellers. It is indeed in this chapter that Shaftesbury terms one popular style

15. Ibid., sec. 6.
16. Shaftesbury, *Characteristics*, vol. 3, *Miscellaneous Reflections*, chap. 1.
17. Not everyone blessed the soul of whoever made miscellanies popular. By 1723 Jonathan Swift could sourly write, in *Of Poetry*, "And when they join their pericranies, Out skips a book of Miscellanies."

of philosophical writing, definitely not his own favorite, that of "these Gladiatoreal Pen-men." The "gladiator theory of truth" was clearly alive and well in Shaftesbury's time, and Shaftesbury is with contemporary feminists and others[18] in wondering if we cannot conceive of reasoning and of truth in less aggressive terms.

What Shaftesbury has done with the term "reason" is to hold steady that part of its Lockean meaning which made it an honorific title, reserved for what we think makes us superior to other animals, while varying the descriptive meaning of the term "reasoning," letting it include everything *he* especially valued in our human mental capacities. Since he valued all sorts of reflections, and reflective conversations, including those that were witty, irreverent, and miscellaneous in their topics and logical structure, Shaftesbury's "reason" comes to include all of this. No particular priority is given to arguments that force a conclusion on us, nor even to reflections that arrive without any coercion at some conclusion, over those that are more tentative, and raise interesting questions. What is more, Descartes's preferred unity, the imprint of one thinker's logical mind, is replaced by a delight in variety, miscellany, crooked mental streets, and entertaining byways. The art of the agreeable digression becomes an exercise of reason.

What Hume at first does with the Lockean concept of reason is the reverse of Shaftesbury's move. He holds fast to the descriptive content of Lockean "reason" as that which enables us to be reasoners, in the sense of discoverers of truth and falsity, inferrers of new truths from old truths, while refusing to honor this capacity above others that we possess, in particular over taste, including a taste for wit, or over the moral sentiment. So inferential reason is toppled from its Lockean throne and made into a servant of human tastes and reflective sentiments. But Hume does not keep up this strategy for very long. In his later writings, especially the *History of England,* he

18. See Robert Nozick, *Philosophical Explanations* (Cambridge, Mass.: Harvard University Press, 1981), pp. 4–8.

switches to the Shaftesburean tactic of letting the term "reason" serve as a sort of title to be conferred on whatever human mental capacities are deemed of greatest value. Hence he can write, in the first appendix to the *History*, of virtue as "nothing but a more enlarged and cultivated reason." This is no late conversion to the views of Samuel Clarke, but rather a capitulation to the established honorific force of the term "reason," an alliance in terminology with Shaftesbury, with whose substantive views he had always been in fairly great agreement. What unites them is the emphasis on the social or conversational nature of the reason they honor, their latitudinarian tolerance for a great miscellany of forms of reasoning, and their shared appreciation of the preferability of enjoyable such forms over unduly solemn and rigidly rule-governed forms. In their singly authored "treatises" they treated of conversations, and of the various prerequisites for "conversing together on reasonable terms" (*T*, 581).[19]

Descartes of course had engaged in written conversation not only with himself [20] but with plenty of fellow philosophers (more, as far as the record goes, than Hume did), and did try his hand at writing in the dialogue form (the unfinished *Search for Truth*). As far as literary form, and actual practice of exchange of views goes, there is no real contrast between those who took reason to be an inborn capacity, complete in each person, and those who took it to be the socially cultivated out-

19. Here and in future citations, *T* = David Hume, *A Treatise of Human Nature*, ed. L. A. Selby-Bigge and P. H. Nidditch (Oxford: The Clarendon Press, 1978).

20. Indeed the reasoning of Descartes's masterpiece, *Meditations on First Philosophy*, is best understood as a long conversation in which suggestions are made, replies that raise some worries are made to them, revised suggestions are then made, often embodying concessions, new doubts are expressed and answered, and new versions keep being offered of what had earlier been accepted as true. This exemplary piece of reasoning is anything but a deductive exercise in the sense that beginning students in logic engage in such exercises. Descartes's *Second Meditation* list of modes of thought (doubting, understanding, affirming, denying, being willing and unwilling, imagining, and sensing), obviously should be extended to include all the more obviously conversational things he acknowledges doing—putting claims forward, admitting, pretending, deceiving, challenging suspected deceivers, saying, declaring, asking, inquiring, examining, calling an intermission, taking careful note, affirming, denying, refraining, complaining and withdrawing complaints, recognizing rights and refusing such recognition, granting, acknowledging, hearing reports, calling into doubt, heedlessly accepting, accurately defining, making an observation, dismissing as laughable, receiving conflicting reports.

come of a certain inborn intelligence and capacity for language, so that it was incomplete until actual conversations on reasonable terms were going on. The disagreement between a Cartesian or Lockean individualist notion of reason and a Shaftesburian-Humean social concept of it may be largely a philosophical disagreement. But those of us holding a social view of reason need not undervalue a disagreement simply because, without a conversation between philosophers, it could go unnoticed.

Locke famously believed that "God has not been so sparing to man to make them barely two-legged Creatures, and left it to *Aristotle* to make them Rational."[21] He, like Descartes, preferred to see reason as something we needed no other human person, Aristotle nor anyone else, to enable us to possess. But because we are, as Aristotle himself emphasized, ones who associate with others, who speak and who laugh, as well as ones who infer, and because our sense of humor, our speech, and our understanding of reasonable terms for our conversations, do pretty obviously depend on the presence of other people, and on the cultivation of standards of inference, of speech, of conduct in conversations, of wit, of moral evaluation, of ways of arriving at agreed terms in a variety of our mutual dealings, then we are none of us really self-sufficient in our reason and our rationality, however capable we may be, in maturity, of composing meditational handbooks in our solitude, or in making our own lists of the god-given individual rights that no community should deny us. Such individualist input into the continuing conversation of beings who pride themselves on their possession of reason can be of enormous value. One who rejects Descartes's or Locke's individualist conceptions of reason need not reject their challenge to particular social authorities who claim to be the arbiters of right reason. In agreeing with Hobbes that "no one man's Reason . . . makes the Certaintie" we need not agree with him that we must, therefore,

21. John Locke, *An Essay Concerning Human Understanding*, ed. P. H. Nidditch, bk. 4, chap. 17, sec. 4.

14 *Lecture I*

"set up for Right Reason, the Reason of some Arbitrator or
Judge," some actual social authority.[22] We must have social
standards of relative rightness of reasoning, but no one author-
ity need be acknowledged as licensed to "make the Certaintie."
We can live with uncertainty, and indeed one of the striking
things about Shaftesbury's defense of his latitudinarian notion
of reason is how accepting he is of the inconclusiveness and
open-endedness of the "reasonings" he celebrates. Locke
rightly associated "positive assertions" with "the magisterial
air,"[23] and Shaftesbury is with his teacher in preferring both the
skeptic's suspense of judgment and the skeptic's refusal to defer
to would-be masters of doctrine.

A social view of reason does not doom one to undervaluing
independent thinking, nor to overvaluing deference to the
thought-community in which one grew up. But it does incline
one to a proper gratitude to those who taught one all the mis-
cellaneous arts of reasoning, and it does give one pause before
demanding (in Hobbes's words), "that things should be deter-
mined by no other men's reason but their own . . . bewraying
their want of right Reason by the claym they lay to it."[24]
Indeed, one can be grateful even to those who indoctrinated
one in the views one later comes to reject. One good stimulus
to independent critical thinking is an offensive demand for con-
formity. Descartes and Locke may have owed more than they
acknowledged to those who taught them the styles of thinking
that they repudiated. As Descartes made very clear, a crucial
move in reasoning, even in its narrowest sense, is negation or
denial, and the denier needs some affirmer to supply her with
material for her negating moves. Occasional independent
thinkers go on to reject the given agendas, not just to oppose
what others have proposed, but the normal progression of dissi-

22. Hobbes, *Leviathan*, chap. 5.

23. John Locke, *Some Thoughts Concerning Education* (Menston, England: Scolar Press, 1970); sect. 145.

24. Kant, in the *Anthropologie*, bk. 1, sec. 53, echoes Hobbes's words when he says that it is typical of the mad to show *Eigensinn* rather than *Gemeinsinn* or *sensus commu-nis*.

dent thought is dialectical, content to inherit topics, parasitical on opponents.

Mary Wollstonecraft's revolutionary *Vindication of the Rights of Women* followed on her earlier *Vindication of the Rights of Men*, itself a contradiction of Edmund Burke's *Reflections on the French Revolution.* She inherited the topic of equal rights, contradicted those who were contradicting the French revolutionaries' declaration, then inferred correctly that true equality must include women. She changed no agendas, and her radical moves were mainly a continuation of her earlier *Advice on the Education of Daughters,* since the education of women, not their political status, is what she wanted reformed, and concentrated on, in her two *Vindications.* To accept the old natural rights conceptual scheme, and a lot of the patriarchal preconceptions about daughters' destinies as child minders, and to wage a campaign to improve the status of women within those constraints, was to adopt a tacit policy that many feminists today still adopt, of letting the terms of the debate be set by the other side. And even when one tries not to do that, tries to set new agendas and forge new concepts, one is bound to be defining at least some of the new issues and new terms by contrasting them with the old. Some intellectual and moral inheritance seems inevitable, even for would-be revolutionaries.

The long exclusion of women from full participation in what Hume called "the feast of reason" was itself a stimulus to some women, such as Wollstonecraft, a stimulus to their reason and their thoughts about their own and their daughters' education. It may even have contributed to the extent of the variety of forms of reasoning that eventually go into the sort of miscellany of reason that Shaftesbury celebrated. Hume believed that including women in conversations would add a certain polish and refinement to them, and one need not accept any gender essentialism to agree with Hume that, if women have been educated and reared differently, and allotted different tasks from men, and then come to be included in what had been all-male conversations, they will then usually have a distinctive contribu-

tion to make. Today, when women in our culture are not so dif-
ferently educated from men, nor restricted to a few occupa-
tions, women's contribution to public reasoning is likely to be
less distinctive.[25] But the inclusion of women (and men) from
other and formerly excluded cultures will have the same sort of
salutory effect as eighteenth-century women had in the conver-
sations of their time, bringing new perspectives, and new styles
of conversational procedure.

The inclusion of British, American, and European women in
the conversations of intellectuals and the deliberations of
reformers preceded by a long period their full inclusion in polit-
ical life. Suffrage lagged far behind other kinds of inclusion in
the activities of reason. As John Rawls uses the phrase "public
reason," only political deliberation, at its various levels, counts
as "public" reasoning. "Public" contrasts, for him, not with
"private," since "there is no such thing as private reason,"[26] but
with various associational or social reasons, which he terms
"nonpublic." He writes "there is social reason—the many rea-
sons of associations in society which makes up the background
culture; there is also, let us say, domestic reason—the reason of
families as small groups in society, and this contrasts both with
public and social reason. As citizens, we participate in all these
kinds of reason, and have the rights of equal citizens when we
do."[27] I take it that by the last sentence Rawls is not extending
the term "citizen" beyond the political sphere. He is not mak-
ing the implausible claim that equal rights typify membership in
every association from family to hierarchical churches. Rather, I

25. But some still discern gender-related difference in styles of thinking. A male
former student of mine recently reported how, after a long discussion with a male col-
league about a philosophical text he had studied with me, a discussion in which he quite
properly insisted that the order in which the author made his claims be taken seriously,
and the recapitulations examined for shifts in emphasis, his exasperated discussant
protested "My God, you are thinking like a girl!" I am very pleased to be able to add
that my former student accepted this judgment so thoroughly that, when he later saw
the dedication I made of *Moral Prejudices* to my women students, he let out a hoot of
joy, taking himself, he supposes, to be included. So should we say "vive la différence"?
That way, we can get more and more honorary women. For if to be a careful reader of
philosophical texts is to be an honorary woman, then we certainly need more.
26. John Rawls, *Political Liberalism* (New York: Columbia University Press,
1993), p. 220, n. 7.
27. Ibid.

take it, he is saying that, as citizens, as members of a political society, we have an equal right to be members of other associations, within which, however, our rights may be very unequal. Not all of these nonpolitical associations are voluntary ones. Membership in a family, in a school, and often in a church, is initially nonvoluntary. A child finds herself in a family, in a school, and perhaps in a church, and finds that her voice in its reasoning is anything but equal to that of the "head" or heads of family, school, and church. Nor, even when adult, may her recognized right be to a voice that is equally heard. Her participation in domestic, ecclesiastical, and other social reasoning may be far from equal, and not likely to be made more equal by state intervention. So it is not at all clear how one's status as citizen, even as free and equal citizen in a constitutional democracy, affects one's equality as a participant in the reasons, in Rawls's sense, that provide the "background culture" to public (i.e., political) reason. It is unlikely that formal equality of political opportunity, and of basic liberties, will be anything more than formal, if there is gross inequality in most of the background associations within which reasoning goes on, in which young people learn to reason and to deliberate. Political reasoning is not, as an individual capacity, sharply separable from all other sorts of practical reasoning. There is a sense in which reason is a unity, however important it may be, in some contexts, to distinguish its political expression from its other expressions.

Women came to be able to effectively campaign for suffrage, and so for equality of voice in political reason, only because some of them had already achieved some approximation to equality of voice in intellectual and literary circles. Maybe the voice that some had in domestic reason also helped—it gave them the will and assertiveness[28] that the suffragettes needed. It is a tricky question just what the relation is between political equality of status and equality of status in other associations within which reasoning goes on. Rawls may assume too great a

28. Hume, in his essay "Of Love and Marriage," suggests that the notorious bossiness of wives in the home is due to their exclusion from other places where bossing went on.

separability among the various reasons he distinguishes, and assume too readily that political reason, because it is reasoning about the proper use of the state's supposed monopoly of coercive force, dictates the terms for nonpolitical reasons. The state has not taken authoritarianism and coercive force out of homes, schools, churches, and other associations, and probably could not, even if it tried.

Public reason, in Rawls's sense, is limited in what it properly considers and deliberates about. But reason in its other social manifestations is typically not thus limited. Ecclesiastical reasoning has not restricted itself to deliberation about the salvation of souls, but ranged widely over all sorts of fields, metaphysical, moral, and physiological. Aquinas did not take his theological reasoning to have to recognize some topics as off limits, and if Rawls is right in thinking that political reasoning should observe some limits (in part to keep the separation of church and state), then that makes it atypical, not typical, as a form of social reason.

Reason has traditionally been thought of as an alternative to violence, not just because conflicts may sometimes be resolved by discussion, but because even when they are not so resolved, verbal aggression may serve as a less lethal substitute for armed aggression. Freud said that the bringer of civilization was the first person who hurled an insult rather than a spear at another. But only if the verbal exchanges, hostile or peaceable, are seen by all parties as being conducted on reasonable terms, will talk mitigate violence. Condescension of the powerful to the less powerful, or merely token inclusion of formerly excluded groups, can worsen rather than defuse the hostility. One recourse of excluded groups is separatism, setting up their own rival "feast of reason," but this move is against the spirit of reason itself, if this is taken to be what we pride ourselves *unites* us. If miscellaneous versions of reason, from miscellaneous sources, including groups once denied full possession of the privileges of reason, really are to unite us in a way we can all take pride in, then reason will have to take the form of tolerant dialogue. Right reason is patient, attentive, good natured, very miscella-

neous and not always very structured *reasoning together.* It is inclusive rather than exclusive in its tendencies.[29] One thing it can include is backward glances at the attempts of earlier generations of reasoners to become conscious of just what this valued activity is, and how much disagreement about it we can live with. Only if reasoning does include such recollective digressions can this lecture count as reasoning. And that I would like it to count as reasoning itself confirms Locke's, Kant's, and Dugald Stewart's point, that reason is what we pride ourselves in possessing. Even the antirationalist, even the skeptic, wants to be seen as reasoning against some pretensions of reason. In Hume's famous words, reason's "enemy . . . is oblig'd to take shelter under her protection, and by making use of rational arguments to prove the fallaciousness and imbecility of reason, produces, in a manner, a patent under her hand and seal" (*T*, 186). One advantage of a social conception of reason is that debate about the proper pretensions of reason can be seen as a natural part of reason itself, and one that feeds on diversity of inputs, on miscellaneous mutually correcting conceptions of reason.

29. But of course there are some exclusions. I have explored one of them in appendix 1.

Lecture II:
Intention

We reason together, challenge, revise, and complete each other's reasoning and each other's conceptions of reason. And we presumably intend to continue this complex exercise, in all the miscellaneous forms it assumes. Hume writes that

> the mutual dependence of men is so great in all societies that scarce any action is entirely complete in itself, or is performed without some reference to the actions of others, which are requisite to make it answer fully to the intention of the agent. The poorest artificer, who labours alone, expects at least the protection of the magistrate, to ensure him of the fruits of his labour. He also expects that when he carries his goods to market, and offers them at a reasonable price, he shall find purchasers, and shall be able, by the money he acquires, to engage others to supply him with those commodities which are requisite for his subsistence. (*E*, sec. 7, pt. 1, p. 89)[30]

Hume makes this point about the incompleteness of most of our actions if they are not completed by the expected responses of other agents not, as my citing of him here might suggest, to persuade us that there are common intentions behind the operation of the market, nor primarily to draw attention to the mutual trust that makes ordinary business dealings possible, but rather to persuade his readers that we have reason "to affirm that all mankind have always agreed in the doctrine of necessity," according to his definition of that contested concept. His main point in this passage is that we do confidently predict and rely on others' voluntary actions. "In proportion as men extend their dealings, and render their intercourse with others more complicated, they always comprehend, in their schemes of life, a greater variety of

30. *E*, here and hereafter = *Enquiries*, ed. L. A. Selby-Bigge and P. H. Nidditch (Oxford: The Clarendon Press, 1975).

voluntary actions which they expect, from the proper motives, to cooperate with their own" (Ibid.). He seems to take motive and intention to be located within each single agent, whose individual intention is accompanied by expectations about how others are motivated, and about what they are intending and doing. Indeed he speaks, here and elsewhere—such as in his famous account of convention—as if the natural place to start, in a philosophical analysis of how we behave, is with a solitary agent, who then has dealings with others, leading on to more extensive and complicated such dealings. But he also emphasizes how any intentions we have concerning property, promise, marriage, or government depend upon those collective intentions he calls conventions,[31] and he is also quite clear about the fact that we all begin our lives as children, so that what we intend and do is initially done in a

31. Convening is just one of a huge class of English action verbs beginning with the prefix "con" or its variants, and very many of those verbs do not occur at all without this prefix. Convening is coming together, but there is no verb to "vene." Nor is communicating "sharing" our "municating" with some privileged other, it just is something that, like tangoing, takes more than one person to do. Collaborating, colliding, commingling, engaging in combat, comforting, commanding, commemorating, commending, commenting, engaging in commerce, comminating or threatening, commiserating, committing, serving on committees, communing, accompanying, compelling, compensating, competing, complaining, making compliments, complying, conceding, conceiving a child, attending concerts, going into conclaves, achieving concord, concurring, condemning, condescending, condoling, confederating, conferring, confessing, confiding, confirming, getting into conflicts, congratulating, congregating, attending congresses, conniving, conquering, conscripting, consenting, being considerate, conspiring, making and accepting constitutions, consulting, contemning or despising, contesting, contracting, conversing, convicting, convincing, and convoking are all activities of the sort Hume emphasized, ones that one person can do with complete success only if others play their role. (These roles need not always be played at the same time.) In many of these cases, of course, there is an active and a passive role for persons, so there is no trouble at all about using many of these verbs with a singular subject which does not imply a plural subject for that very verb. Not all of the activities referred to by these verbs lack a solo form, got linguistically by dropping the prefix *con*. As a conclave is a confidential meeting, behind one locked door, and allows the possibility that the secret began as one person's, who then shared it (and the key to the meeting room) with others, so, strictly, to condemn is to inflict on another some doom, damnation, or damage which theoretically might have been self-inflicted or inflicted by impersonal fate; to condole is to feel pain, or be dolorous, with another; to congratulate is to express joy (Latin *gratus*) with another. We have no verb to "gratulate," any more than we have any verb to "dole" or be in the doldrums, but there is nothing essentially multipersonal about the activities and states which many of these verbs point to. But for some of them it is hard to see how Robinson Crusoe, before Friday's arrival, could possibly have engaged in them, let alone planned to engage in them. He might congratulate himself, comfort himself, condemn himself, compel himself, but if he were to communicate, confide, conspire, have concerts, compete, accompany, it would have to be with the birds and the beasts. No question of committees or constitutions could arise, except in his memory, contingency planning, or dreams.

family setting, with the assistance and guidance of older family members. Indeed, in order to acquire the sort of competence and control that makes voluntary action possible, and to understand our responsibility for it, the assistance of more accomplished others is well-nigh essential to initiate one into full agency. When Hume is dismissing the Lockean thesis that we can derive the idea of necessity and causal power from the operation of our own wills, he emphasizes that only experience informs us that the will has "an influence over the tongue and fingers, not over the heart or liver," and that self-command, the mind's command over itself, is known by experience to "be very different at different times" (*E*, 68). His examples of lessened self-command, in this passage, are illness and tiredness, but early childhood could easily be added, since Hume takes it to be part of the parents' role, with respect to their children, to "fashion them for society" by "rubbing off rough corners and untoward affections" (*T*, 486). If, once a person is old enough to be held accountable for her actions, she is expected to display the virtues of self-command and resoluteness, and knows that "design'd and premeditated" actions are more likely to be punished than unintended doings, since "an intention shews certain qualities, which remaining after the action is perform'd, connect it with the person" (*T*, 349), she will form and stick to her intentions in the light of what she knows are the likely responses to them by her fellows, especially those to whom she is accountable, and she will be glad of what help she has received earlier in acquiring self-command, especially over any "untoward affections."[32] Our customs of child rearing

Many other prefixes, such as *apo*, connoting a defensive attitude (apologize, oppose, appeal); *inter* (interrupt, intervene); and *anti*, *ad*, and their variants (antagonize, address, aggress), would enable us to extend the list of activities which Crusoe would have trouble engaging in, without cooption of animals.

32. Hume's use of "untoward" here is a variant of Hobbes's "froward," in his commentary on his fifth Law of Nature, "that every man strive to accommodate himself to the rest," and fifth virtue, being "*Sociable* (the Latins call them *Commodi*) the contrary, Stubborn, Insociable, Froward, Intractable." (The O.E.D. gives "froward" as the opposite of "toward.") (Hume's companion reference to the "rough corners" that parents are to smooth in their children also seems to pick up Hobbes's reference, in his explanation on his fifth law, to the "asperity and irregularity" of some stones that builders have to cast away as "unprofitable and troublesome.") So the parent's task, as Hume sees it, may be more to help the child avoid the particular vices of "frowardness" and "asperity" than to avoid vices in general, the "untoward" in our modern sense.

and of certifying competence are geared to our practices of hold-
ing those who have reached "the age of reason" responsible for
their actions. The intentions behind each of these social practices
"cooperate" or "concur" with the others.

We can acquire new competencies throughout life, and some
believe we can go on improving in self-command. Hume has a
low estimate of an individual person's chances of changing her
passions and affections for the better, or of acquiring self-
command, once childhood is past. If he is right, splenetic adults
will not be likely to lose their spleen by self-reformation cam-
paigns, nor will "weakness of mind" (i.e., will) be magically
turned, by efforts of that will, into strength. Hume gives a vivid
description of that "infirmity of human nature" which makes
lesser close goods more appealing than remote goods, even
when the latter are acknowledged to be greater: "This natural
infirmity I may very much regret, and I may endeavour, by all
possible means, to free myself from it. I may have recourse to
study and reflexion within myself, to the advice of friends; to
frequent meditation and repeated resolution: And having expe-
rienced how ineffectual all these are, I may embrace with plea-
sure any other expedient by which I may impose a restraint
upon myself, and guard against this weakness" (*T*, 536–37).
Since we do often regret our shortsighted actions, we "embrace
with pleasure" what obviates the choice between close and dis-
tant goods. And because we do take pleasure in removing the
conflict between close and distant goods, it is our flexible capac-
ity for pleasure that provides the remedy to the temptation to
go for the closest pleasure at the expense of the greater good.[33]
Thus "this infirmity of human nature becomes a remedy to
itself" (*T*, 538). "Men are not able radically to cure, either in
themselves or others, that narrowness of soul that makes them
prefer the present to the remote. They cannot change their
natures. All they can do is change their situation" (*T*, 537). The
effective situation-change Hume is recommending here is the
move from absence to presence of governmental authority,

33. Tito Magri has helpfully explored this Humean theme, in "Hume and Our
Motivation to be Moral and Rational," unpublished manuscript.

magistrates who can attach immediate costs to close tempting lesser goods, and so alter effective motivation. This is a change of social conditions and of culture, bringing with it a change of motivation in individuals, just as, in infancy, the presence of loving parental authority can effectively shape a child's motivation so that what Hobbes called "Mutuall Accommodation or Compleasance," what Hume calls "coalition," will be facilitated, rather than hindered, by the individual's effective motivation.

It is, therefore, by a complex interaction between social customs, such as parental and governmental authority, and the authority of those who certify others' competence in particular fields, along with ways of changing such customs, and natural but malleable ability and motivation, abilities to do such things as walk, talk, write, along with such motives as parental love, children's wish to please their parents, native curiosity and delight in achievement, and some willingness to cooperate when cooperation promises benefit, that the standard competences and dependable motives that influence adult conduct are, on Hume's account, formed. We need postulate no mysterious community skill over and above individual skills, no mystic community will over and above individual wills. But, on the other hand, we cannot do full justice to the full range of intentions that individuals can form, such as the intentions to exercise the ability to give an eloquent speech in parliament, to buy and sell, to vote, to stand for office, to make a promise, to refuse to accept a promise, to make an accusation, to give an excuse for what one admits having done, unless we take account of the customs and conventions which have grown up in the individual's group.[34]

34. I have explored this theme in "Doing Things with Others" (Tenth Inter-Nordic Philosophical Symposium on Ethics and Understanding, Academy of Abo, Finland, August 20–22, 1993; essay published in *Commonality and Particularity in Ethics*, ed. Lilli Alanen, Sara Heinämaa, and Thomas Wallgren [New York: Macmillan, 1996]). Some of what is argued here repeats points made there, but the link with trust was not developed in that paper. My earliest exploration of this theme was in "Intention, Practical Knowledge, and Representation," in *Action Theory*, ed. M. Brand and D. Walton (Dordrecht: D. Reidel, 1976) reprinted in *Postures of the Mind*. Further explorations of it occur in "Mixing Memory and Desire," "Mind and Change of Mind," and "Cartesian Persons," all in *Postures of the Mind*.

Of course it is equally true that unless most of us, as individuals, are not rebelling against the existing customs, it will not be true that they are the ongoing intentional policies of the group, not true that *we intend* them. The dependency between what I intend and what we intend goes both ways. And the smaller the group, the "us" of which I am a member, the easier it will be for me singly to wreck the collective action by opting out, by refusing to go along. It takes two, but only two, to tango, so if I refuse then we do not tango. But if the large family group of which I am one is dancing a highland reel, and I withdraw, the collective dance will go on. Should a new arrival ask me "what is going on?" I could correctly answer "we are dancing a reel," perhaps adding "but I quickly had enough of it, so am sitting out." Larger groups can more easily find room for nonconformers to the group intentions than can pairs. Yet when recent philosophers such as John Searle[35] and Michael Bratman[36] have turned their attention to collective intention and collective action, they have chosen pairs of persons, and so have seen the collective intention as no more than the coordination of two individuals' intentions.[37] Bratman has a couple painting a house together—essentially doing the same thing as each other, on different bits of the house's walls, and doing something all of which *could* be done by one alone, doubtless not so quickly. All that many hands do is make light work, not transform the nature of the work, nor the competencies needed to perform it. Searle has a couple making a hollandaise sauce, one stirring while the other pours. Four hands makes this easier to do than two, but it is not impossible for two. It is often sensible for individuals to team up and both paint, or combine efforts to get the sauce smooth; but it is not essential to the activity itself, in these cases, that there be a team doing it, as it is, for example, if what is to

35. John Searle, "Collective Intentions and Actions," in *Intentions in Communication,* pp. 401–15.

36. Michael E. Bratman, "Shared Cooperative Activity," *Philosophical Review* 101 (April 1992).

37. An exception here is Gerald Massey's path-breaking "Tom, Dick, and Harry and All the King's Men," *American Philosophical Quarterly* 13 (1976): 89–107, which discussed "multi-grade" predicates that can take conjunctive subjects, as in his apt title. He treats the latter as "sum individuals."

be done is that a symphony be conducted and played, a law enacted, or a marriage performed.

Locke writes "Amongst all the *ideas* that we have, there is none suggested to the Mind in more ways, so that there is none more simple, than that of *unity* or One. . . . By repeating this idea in our Minds, and adding the Repetitions together, we come by the *complex* Ideas *of the Modes of it.* Thus by adding one to one, we have the complex *Idea* of a Couple."[38] The idea of a couple, say the couple who are being married, is treated as a 'mode' or modification of the idea of each member of the couple. The single person is the simple, more basic, starting point for the Lockean individualist, even if it is acknowledged that that one person must have a couple of parents. (Actually Locke avoids having to acknowledge this, by his separation of the concept of "person" from that of "man" or "human being.")[39] Modern Lockeans in action theory, when they look at what a pair or group of persons can do, take it for granted that such multiperson actions are more complex than single-person actions, and indeed are "modes" or modifications got by combining the elements provided by single persons and their abilities and intentions.[40] Even those, like

38. Locke, *Essay,* bk. 2, chap. 16, secs. 1 and 2.

39. I alluded to this aspect of Locke's discussion of persons in "A Naturalist View of Persons," Presidential Address delivered before the Eighty-Seventh Annual Eastern Division Meeting of the American Philosophical Association in Boston, Mass., December 29, 1990. *Proceedings and Addresses of the American Philosophical Association* 65 (November 1991): 5–17. Reprinted in paperback edition of *Moral Prejudices: Essays on Ethics* (Cambridge, Mass.: Harvard University Press, 1995).

40. Jon Elster, in *The Cement of Society* (New York: Cambridge University Press, 1989) is another philosopher who typifies the dogmatic individualist bias of most analytic social philosophers and action theorists. Completely ignoring mother-child symbiosis, Elster writes "There are no societies, only individuals who interact with each other" (p. 248). Interaction between individuals is the correct way to see very many social activities, but not all. We make unnecessary philosophical problems for ourselves if in our philosophy we forget that individual action was something we all had to learn, and that we learned it as a departure from common action. Social norms become mysteries if we suppose, as Elster does, that socially useful norms evolved either by chance or by rational agreement between fully fledged self-interested individualists. After a splendid survey of all the sorts of social norms which influence our action, and a swift rejection of evolutionary explanations of them, he concludes "Norms are not fully reducible to self interest. . . . The unknown residual is brute fact, at least for the time being" (p. 150). Elster had begun his book by referring to the deep pervasive "problem of collective action," "the problem of free riding" (p. 17). Free riding becomes a problem only when adult individuals are getting their rides free. For the unborn child, free riding in a fairly literal sense is unavoidable, and for most of childhood free riding in only slightly

Margaret Gilbert,[41] whose special concern is to do justice to the reality of "plural subjects" and the action of collectives, are Lockean in supposing that individuals must "pool their wills" to be ready to engage in shared action.

If persons, those who can form intentions and share intentions, are metaphysical souls, requiring at most God for their genesis, then this individualism is plausible—no collectivity need be referred to to explain what each of them is and can do. But if they are living human persons, necessarily born of two parents who together engendered them, necessarily separated from the mother's body by someone playing the role of midwife, necessarily a member of some group who helped them learn to do the sorts of things that human persons do—walk, at first with others, later alone, talk with others, form plans, justify or excuse their plans and actions to others, conduct orchestras, elect or lead governments—then it becomes more questionable that the concept of an individual person does not require, for *its* analysis, the concept of any collectivity. Parents or their functional equivalents do seem required to play the role of physical and psychological engenderers.

less literal senses is also the norm. Those who provide these free rides may make it their business to impart to their young some of Elster's "norms of reciprocity," in the expectation that in their infirm old age they may be carried by those whom they once carried, but such expectations vary from society to society. In any case, attention to the norms structuring the behavior of parent and small child would free us pretty quickly from our moral prejudices favoring the assumption that self-interest is our main motive and that common action is problematic in a way that individual action is not. Elster cites the social taboo against cannibalism as one of those useful social norms whose origin he finds so mysterious. He writes: "Everybody benefits from a norm that forces people to look elsewhere than to other people for their food" (p. 141). Once again, he shows the usual philosophical amnesia of the plain facts of gestation and breast feeding. Our norm is more complicated and more interesting than Elster makes out. Like most norms, it reserves a certain important right to some, denying it to others. A restricted form of "looking to others for their food" is encouraged in infants, and those to whom they look are helped not harmed by their infant parasites. Weaning puts an end to this special permission, and is as important a stage in the child's becoming an individual as was the cutting of the umbilical cord. The child slowly, but only slowly, learns to do things for herself, rather than always with the parent and with the parent's presence and assistance.

41. Margaret Gilbert, *On Social Facts* (Princeton, N.J.: Princeton University Press, 1992), p. 435. Gilbert espouses what she terms "weak analytic individualism," weak because she denies the reducibility of "plural subject" intentions and actions to a plurality of single subject intentions and actions, individualism because she argues in support of the Lockean claim that "the concept of an individual person does not require, for *its* analysis, a concept of a collectivity itself unanalyzable in terms of persons and their non-collectivity-involving properties."

Of course a new person can be conceived and born without any intentional action on the mother's part, and without the intention to procreate, on the father's part. If the mother is a victim of rape, and has no knowledge of methods of abortion, she herself may not be part of any collectivity responsible for the newborn person; indeed only one dominant male may be responsible. But this, surely, would be agreed to be the exception not the rule. Even if it were a statistical norm, I do not think that many analytic individualists would welcome resting their individualism on the brute fact of the possibility of pregnancy by rape. Much more likely, I surmise, would be their indignant rejection of any such facts about the *genesis* of individual agents as of relevance for the analysis of the competences of such agents, once mature. I will be accused of the genetic fallacy if I point to the fact of the need for plural parent action to engender and nurture any agent. Since the child does eventually reach a point in time when he can walk alone, dress alone, get his own meals, read for himself, plan for himself, decide for himself what groups he does or does not associate with, he grows into an independence he did not begin with, and it is this adult, or more accurately this adolescent competence, which the analytic individualist chooses to focus on. Why, it will be asked, must we keep the memory of our incompetent dependent infancy, and of our dependence on a pair of parents for our very existence? Can we not, like Descartes, simply deny that we depend on them, or any past helpers, for what matters now, our adult capacities for thought and intentional action?

In a sense there is nothing wrong with taking this line, since it is undeniable that adults can, if they choose, be hermits, restrict their intentional actions to those that do not depend for their success on what others are doing. And those who, like most of us, do engage in activities that require for their possibility of success that others be doing their part in some coordinated scheme of actions, are currently dependent on our contemporaries, rather than on our past helpers and educators. So surely it *is* a fallacy to suppose that because we once really

needed helpers, we are still dependent? Do we not replace
inevitable dependency on unchosen parents and other care-
givers with chosen mutual dependency in voluntary associa-
tions? So is it not our current choices, rather than our genesis,
that determine any current mutual dependency? Up to a point,
this is undeniable. But we have little real choice about depend-
ing on *some* social infrastructure, as we make our individual
decisions about a profession, about travel, insurance, retirement
income. And most of us are involved in the care of either
younger or older partially dependent persons, so are still operat-
ing within the ongoing cooperative scheme that tries to ensure
that the very young get cared for, so that, among the other
things they are enabled to do, they some day can *give* care, and
that the old who in their time gave care, get care when they
need it. The "genesis" of competent adults is an ongoing mat-
ter, in which we, or most of us, change our roles, but are never
really finished with the process. This most vital cooperative
scheme of all is admittedly one which a grown person can opt
out of, refusing to take on any care-giving roles, content to let
some portion of her taxes, and nothing more than that, be her
contribution to the continuation of the scheme to which she
owes her existence as a competent agent. But this free riding on
the generative[42] scheme that produced us, not to mention on
the cooperative scheme between overlapping generations that
softens the indignity of final incompetency and the pain of ill-
ness, seems at best churlish, at worst manifestly unjust.

Precisely because of the centrality for the quality of all lives,
and for the planning of lives, of these social procedures by
which the very young, the ill, and the old get care from those
no longer or not yet needing such care, many of those who tra-
ditionally did more than their fair share of the caring have
recently protested the inadequacy of versions of justice which
abstract from the justice of this scheme in which we all have

42. Sibyl A. Schwarzenbach, in "A Political Reading of the Reproductive Soul in
Aristotle," *History of Philosophy Quarterly* 9, no. 3 (July 1992): 243–64, and "On Civic
Friendship," forthcoming in *Ethics,* calls this sort of activity "reproductive" of the life of
the community.

been, and likely still are, involved. From Antoinette Brown Blackwell[43] to Carol Gilligan, Susan Okin, and Sibyl Schwarzenbach, the ongoing generative and "degenerative" cooperative scheme has been forced on the attention of reluctant individualists who had preferred to conveniently forget its background presence, there structuring the possibilities for their private plans and ventures. Once pointed out, it is obvious that we all, in our cooperative or solitary enterprises, count on things such as training and certification procedures, professional associations, police protection, insurance of various sorts, ambulance and medical services should we need them, a steady supply of younger persons to provide a labor force, to become nurses, nursemaids, school teachers, bus drivers, and so on. We take service of a great variety of sorts for granted. And we teachers take a steady influx of students for granted, and give any attention at all to what ensures that only when the supply dwindles, or the preparedness of our students for what we want to teach them drops to disturbingly low levels. Only then are we willing to think about the processes that generate and form the people whom we need, for our own current activities.

One might say that we trust[44] that normal generative activity will continue, if trust includes unselfconscious reliance on others continuing to do what we have come to count on their

43. See Mary Ellis Warthe's entry *Women Moral Philosophers,* in vol. 2 of *Encyclopedia of Ethics,* ed. Lawrence C. Becker and Charlotte B. Becker (New York: Garland Publishers, 1992), for information about Blackwell, the first ordained American woman.

44. The connections between the concept of trust, in particular trust in procedures of nurturing and training, and the concept of an intentional action as one that exercises some socially recognizable competence, and for which one is accountable, have only recently become clear to me. My early work on action theory broke off after I had reached the conclusion, in "Ways and Means" (*Canadian Journal of Philosophy* 1 [1972]: 275–93), that the only defensible sense in which intentional actions could be seen always to involve some basic action, was that some basic competence was always exercised, and its recognition involved socially coordinated shared intentions. I was unclear what the next move should be. But then I found myself becoming interested in trust, and from the start saw it to involve both confidence in the competence of the trusted, and the willingness to give discretionary powers, to refrain both from trying to supervise, and from constant calls to account. It has taken me quite a while to realize that my turn from attention to the basic socially recognized competences involved in intentional action to attention to trust was not a blind swerve, nor even an agreeable digression, but a perfectly appropriate next move in my ongoing attempt to understand intentional action, both individual and collective.

doing. It is against this background of familiar ongoing social services that other more self-conscious sorts of trust grow, and sometimes wilt. A climate of conscious distrust develops fairly quickly once, say, police protection becomes markedly undependable, or hospitals become seen more as places where one catches disease than places that cure it. And abrupt changes in matters such as government health schemes or social security can shatter individual lives, by undercutting the assumptions of individual plans. If one has had no warning that one needed to save for old age, because of a longstanding social-security policy, to which one has made lifelong contributions, then suddenly is launched into a "user-pay" policy, it will not be only governments that one comes to distrust. Once the floor on which one confidently stood gives way, one is unsteady in every move one makes.

Trust and distrust are more obvious, and easier to analyze,[45] when they relate two or a few people, than when they are generalized attitudes within whole populations, but even when it is a particular person whom I trust or distrust, the social background will play its role. If I distrust that armed security guard, and fear that guarding me is not really what he has in mind, it will in part be because of his social powers, not only because of his brutal face and threatening stance. If I trust my physician, it will be not just because of her bedside manner but because of the diploma on her office wall, and my vague knowledge of the sort of training she has had. And even in the most intimate sorts of trust, say of spouse or close friend, the cultural background assumptions about such matters as the extent of tolerated domestic violence may play their role. Knowing how a man has been raised, meeting his mother, father, brother, school teachers, all serve to assure a woman that her spontaneous trust and attraction are not too foolish, or else can serve to warn her.

45. I have explored the nature of trust in my Tanner Lectures (*Tanner Lectures on Trust;* in *Tanner Lectures on Human Values,* vol. 13 [Salt Lake City, Utah: University of Utah Press, 1992]), which, along with two other essays on trust, are reprinted in *Moral Prejudices: Essays on Ethics* (Cambridge, Mass.: Harvard University Press, 1994), and also in "La Confiance," in *Dictionnaire de Philosophie Morale* (Presses Universitaires de France, forthcoming).

It is not for no reason that those planning to marry usually introduce their intended spouse to their families, who usually attend the wedding. Nor is it just because the two families will be joined, if the marriage takes place. It is also so that those intending marriage find out more about each other, and they do get information by meeting each other's family. Some engagements do not survive these exposures to families, and so they serve as a useful check. The fragile trust and fallible character assessment between lovers needs to be tested by each seeing the other in the home setting, the setting from which they came, the setting in which their capacities for trust and trustworthiness were forged.

Capacities for trust and trustworthiness develop in tandem. One needs to have known, in some sense of "known," what it is to trust the trustworthy to have any chance of oneself coming to show trustworthiness. The young child, blessed with parents she trusts, comes to try to imitate their trustworthiness, when she herself is trusted. And, as Bacon pointed out, it takes a fairly generous nature to prove true despite being subjected to constant suspicion and distrust. For a child to be trusted is, in the first instance, to be left unsupervised; in the second instance it is to be not expected to give a detailed account of what one did, when unsupervised.

The extent to which one trusts another person, in some activity in which one needs her cooperation, is closely linked with one's willingness not merely not to insist on supervising, but also with one's willingness not to invoke, to the maximal extent that one might have, the pervasive practice that near defines what we take agency to involve, the practice of calling for an account. As Anscombe pointed out, intentional actions are those to which a special sense of the question "why?" applies,[46] and this question asks not just for an explanation but in a weak sense for a justification, a making intelligible of what one is doing to others reasonably concerned about that. Agents are those who can be asked to account for their doings, and who can respond appropriately when so asked. Intentional

46. G. E. M. Anscombe, *Intention* (Ithaca, N.Y.: Cornell University Press, 1957).

actions are the most proper object of our calls for an account, they are, *par excellence,* what we are responsible for. When we trust, we refrain from supervising and we delay the accounting. This does not mean, however, that a climate of trust is one in which accountability has been transcended. Trustworthiness is not an alternative to accountability. Minimal trust, trust that the person will not lie about what she remembers having done, and that she has the capacity to remember and truthfully report it, is a presupposition of our practices of holding people to account, and accountability is presupposed by more extensive trust, the trust that delays, perhaps indefinitely, the request for such an account. Trust in these extensive forms is the whole account-ability practice limiting its own displays, accountability made reflexive. The trusted person may eventually be asked by the truster to give a detailed accounting, and must be willing and able to do this. There would be no significant trust if the reporting back is too frequent, but some reporting back, either requested or volunteered, is quite compatible with a healthy trust relationship. Accountability and the capacity for trust are symbiotic, not mutually exclusionary.

If we think of what accountability itself involves, namely the capacity to control what one is doing, to remember what one has done long enough to report on it, to understand the expec-tations of those to whom one is accountable, and to judge whether or not one has met them, we soon see how much trusting must have gone on, for a person or a group to be in the very position of an agent accounting for her doings. Those we judge to be irresponsible or without competence will not be left free to do anything much, nor held accountable for what they happen to do. For an individual person to be an account-able agent, wisely or unwisely trusted for a while to get some-thing done unsupervised, then possibly called on to account for her acts, social practices of supervision, intermitting supervi-sion, keeping records of performance, calling to account, and delaying such calls have to be in place. Because we in this cul-ture value so highly the liberty that consists in *not* being super-

vised, or being supervised only when we have agreed to be supervised, and really dislike eternal vigilance and invigilation, even when it is the price of liberty, we are likely to resist the suggestion that liberty of action might itself be a social permission, there only if the group waives its right to supervise. We like to see liberty as a God-given, not a society-given, right.

Descartes sees liberty this way, as God-given. Significantly, in the *Fourth Meditation,* where he presents his account of the liberty of the will to affirm, deny, or postpone decision on what intellect offers as candidates for acceptance or rejection, he begins using the terminology of wrongs and rights—wrong choice as a privation, not just a limitation, the right or absence of a right to complain that God has not given one a more perfect intellect, that one's role in the world is not the star role, etc. Once Descartes's meditator explicitly recognizes his own active nature, he starts talking of rights and responsibilities, of going wrong and "behaving correctly" (*recte agere*). Yet it is not *moral* standards he is here invoking, simply the standards that action or choice itself necessarily involves. Legal language is used (*"ius conquerendi"*) and there is talk of having or lacking a cause or *causa;* but the court that is to adjudicate the matter is entirely internal.

One thing of especial interest about Descartes's importation of these deontological concepts into his meditator's thought at this point is the clear inclusion of nondoings as well as doings in what is to be judged, at the human level. One is expected in some cases to "abstain" (*abstinere*), one is at fault if one fails to remember the rule for correct action, or fails to cultivate good habits of action. So the full range of what we are accountable for—not just acting but various forms of not acting, not just intentional action but also forgetting what we should be doing, not just self-conscious but also habitual action or inaction, all get the meditator's attention. They are all cases, for him, of exercises of the basic power he terms "will, or freedom of choice" (*voluntas sive arbitrii libertas*), namely the power to do or not do something (*vel facere vel non facere*).

There need be no feeling of having a choice when will is exercised—indeed the only phenomenological requirement is that we *not* feel determined by an external force. Both when we are making a conscious decision for what look like overwhelmingly good reasons, and when we act from habit, or fail to act, out of forgetfulness, we can be exercising Cartesian will—that is, it can be the case that we have the power to do or not to do something, and that no external force is felt to decide how we act. For all such exercises of Cartesian will, including such things as sleeping in (because one failed to arrange to be woken in time) or making a choice which one would not have made had one bothered to get more information first, one is accountable, one's conduct is liable to be found either at fault (*falli*), or correct (*recte*). So a whole accountability analysis of action is sketched in the *Fourth Meditation,* albeit somewhat distorted by the fact that the only social dimension involved is that of finite actor to infinite "author" behind his acts. This infinite author, with the supreme power of choice, is not the one who is presented as making any complaints about the meditator's errors—the *meditator* is the one tempted to complain, the one upset by his own limitations and errors, the one both thinking of bringing a case against a higher authority, and anticipating complaints being made of his own poor performance, his own errors. So there is a displaced acknowledgment that the normative demands are entirely human. The question raised early in the meditation—"Is it then better [relative to God's decision as to what is best] that I should go wrong than that I should not do so?" is never really answered, perhaps for the good reason that the only standards of goodness accessible to us are our own. To adapt what Descartes wrote in another connection:

> What is it to us that someone should make out that the perception whose truth [and the choice whose goodness or correctness] we are so firmly convinced of may appear false [not good, not correct] to God, or an angel, so that it is, absolutely speaking false [not good, not correct]? Why should this alleged absolute falsity [incorrectness] bother us, since we nei-

ther believe it nor have even the smallest suspicion of it? (*AT*, 7: 145, my additions in square brackets.)

As I am construing liberty, it is a matter of being trusted on one's own, left unsupervised, away from any deontic score-keeper[47] except oneself, given unlimited discretionary powers, and so there must be some truster, some party playing the role of the one who might have but does not supervise or keep score, who leaves one on one's own, who in Descartes's term "concurs" in one's having one's freedom, whose will lies behind one's own free will. Who or what is this? Usually it is whoever is thought to have the right, if what one is doing provokes suspicion, to ask one to account for oneself. "Hey, what do you think you are doing?" is the least formal such request, and could be made by almost anyone who witnesses one's action. The most formal is an accusation in a law court. Between are all the accounting procedures used in various organizations, including those tedious activity reports some of us academics have to make to those who fund universities.

If intentional action is doing something for which we could, if necessary, take responsibility, something we could give an account of to some interested party, then such action is in its essence immersed in intentional social practices such as leaving adults free to conduct their own lives as they see fit (within the limits of the law and of the commitments they have undertaken), of calling them to account on occasion, of trusting them to be able to play their roles in these accounting activities, and trusting ourselves as supervisors and as callers-to-account not to overdo those activities, to understand their role and their relation to the trust that they cultivate and protect and the liberty that they recognize and limit.

I have treated our fundamental practice of holding those who have reached "the age of reason" accountable for their

47. Robert B. Brandom, in *Making It Explicit: Reasoning, Representing, and Discursive Commitment* (Cambridge, Mass.: Harvard University Press, 1994) puts heavy emphasis on "deontic score-keeping."

actions, and the rights and duties that practice involves, as part
and parcel of intentional agency itself,[48] not as part of our prac-
tice of specifically moral evaluation of agents and their actions. I
have, that is, tried to put deontology in its place. It is a Humean
thesis that rights and obligations arise within coordinated social
practices, and that before moral evaluation (or "moral rights" or
"moral obligations") can arise there must first be premoral or
what he in the *Treatise* somewhat misleadingly calls "natural"
obligations and correlative rights. Hume's example of these pre-
moral deontological entities are property rights and the expecta-
tion that they be respected, rather than the right to an account
from those we suspect of having acted in any socially unaccept-
able manner, or the obligation to provide such an account, and
to have acted in a way for which one can satisfactorily account.
But in generalizing Hume's account of the practice-embedded-
ness of all rights, and the supervenience of any moral on pre-
moral rights, from those he discussed to those involved in the
more pervasive practice of demanding and giving accounts of
one's doings, and taking that to be coextensive with intentional
action itself, I am picking up on one conceptual element Hume
himself emphasized—that between intention or design and what
he termed "artifice." He pointed out, in his preliminaries to his
account of property as in his sense "artificial," that one of the
senses of "natural" is that which is opposed to "artifice." Artifice
is then glossed as whatever shows "the designs and projects, and
views of men" (*T*, 474). The artificial and that which was
designed, projected, done with something in view, are here
equated, and so when a little later Hume claims that it is a "very
gross fallacy" (*T*, 491) to make use of the terms *right* and *obliga-
tion* before explaining the origin of justice in "artifice," it is the
link between these deontological concepts and that of intention,
and in particular of coordinated mutually referential intentions,
that he can be read as insisting on.

If Hume is right that rights and obligations are part of the

48. I am very much influenced here by Robert B. Brandom and Katarzyna
Paprzycka, and also by R. Jay Wallace, *Responsibility and the Moral Sentiment* (Cam-
bridge, Mass.: Harvard University Press, 1994).

social subsoil of morality, rather than what it takes morality itself to contribute, and if I and those I have borrowed from are right in seeing these deontological concepts, with the social practices in which they arise, as needed to make full sense of intention and the attribution of intention, then they will be included in what morality evaluates, rather than being themselves an essentially moral coinage. Shaftesbury emphasized how moral evaluation itself presupposes that the evaluated (which he took to be those very characters or characteristics of "men and manners" that gave him his most famous work's title) are characters of those who are themselves self-aware and accountable, capable of "self command." "So that if a creature be generous, kind, constant, compassionate, yet if he cannot reflect on what he himself does or sees others do . . . he has not the character of being virtuous" (*Characteristics,* vol. II, pt. III). A horse may only in a "vulgar" sense be termed vicious, he writes; since the horse is not deemed capable of reflecting on its own character or actions, or on others', we do not attribute to it either moral virtue or moral vice.[49] Shaftesbury does not sharply separate premoral from moral reflection and evaluation in the human case, but he is very clear that morality presupposes accountability and "self command." This can be taken as a proto-Kantian element in Shaftesbury's thought,[50] but if we, like Hume, divorce accountability from metaphysical freedom of the will, and tie it more to the capacity to participate in social practices or "artifices," then we can equally well see it as proto-Humean.

The intentionally sustained practices of asking people to give an account of what they are doing, of answering such questions when they are asked of one, of assessing such answers and, if they are judged unsatisfactory, administering some reprimand or some punishment, of appealing such judgments, repri-

49. Hume gives "virtuous horse" as an example of a complex idea of the imagination, like "golden mountain," in his first *Enquiry* (*E,* 19). Of course between Shaftesbury's *Characteristics* and Hume's *Enquiry Concerning Human Understanding* there had been Jonathan Swift's *Gulliver's Travels,* whose homonyms had aided human imagination.

50. Stephen Darwall takes it this way, in his chapter on Shaftesbury in *The British Moralists and the Internal Ought 1640–1740* (New York: Cambridge University Press, 1995), chap. 7.

mands, and sentences, and settling such appeals, are of course themselves intentional practices which can in turn be criticized, and called to account. To some extent this is what happens when appeals are made, but of course the appeal procedure itself is among the practices that can be asked to account for its doings. Who does this asking, and who answers for the practices? The ones who may ask for an accounting of our procedures of holding people accountable for their doings are all of us who are affected by them. It is our business, in Mill's sense, what form these procedures take. They may be found overly intrusive, or counterproductive and inefficient, or overly time consuming, or unfair to those who are asked to account for their doings, either in the asking or in the follow-up judgments and sentences. Often such criticisms of procedures are moral criticisms, as they will be when fairness is the issue. But they are not always moral criticisms. Who answers for the existing procedures? Primarily those who officiate in them as the askers for an account, as decision makers and sentencers. But all of us who accept such practices, who allow them to continue, can also speak up in their defense, as well as ask for a defense. We can play the roles both of asker and answerer, when it comes to our group practices. And since these practices of holding to account have an in-built tendency to being authoritarian, a tendency that needs careful monitoring, it is important that at some stage, and at the highest stage, accountability be mutual, and that each person play the role both of asker for an account and of answerer.

In my third lecture I shall have more to say about mutual criticism when it takes a moral form, and about how evaluation of our intentional actions is linked with evaluation of other aspects of human beings as minded beings. Our minds show importantly in what we, individually and collectively, are minded to do, and so are accountable for doing, but they also show in how we feel, both about our own and others' actions, and about our situation in general, in how we express our feelings, in how we spontaneously think and feel, as well as in how we control our thought, actions, and feelings.

Lecture III:
Moral Reflection

In the previous two lectures I have defended the view that both our reasoning and the more important cases of our intention-formation and carrying out of our intentions, even when only one person is currently doing the reasoning or the intending, or the carrying out, require a commons of the mind, the background and often the foreground existence of essentially many-person reasonings, intentions, and actions. Of special interest to us who pride ourselves on our capacity for reflection are reasonings, intendings, and actings not merely displaying our mutual dependence but also directed on that very interdependence itself, that is to say, our reasonings, resolutions, and resolute actions concerning what is right and wrong, morally acceptable and morally unacceptable, in our social customs, interpersonal relations, and individual habits, actions, and reactions.

The word "morality" itself declares that *mores,* our customs of coexisting, constitute morality's main subject matter. The natural law tradition in moral philosophy saw this very clearly, even if, in many of its versions, it took the creature's mode of coexisting with the divine creator to be the most important moral relationship, and did not usually see this as a case of mutual dependence. The reflexivity that is exhibited when mutually dependent reasoners and intenders turn their attention onto their mutual dependence was not, indeed, a feature of moral reflection that struck the natural lawyers—those who reacted against them, such as Shaftesbury and Hume, and saw morality's source to lie in our capacity for fellow feeling and for reflexive feelings about our feelings, are the ones who first

emphasized the connection between normativity and reflexivity, a connection Kant adapted for his special version of natural law, a law of freedom, for his version of morality as a law for and by the likes of us, and recognized by the likes of us, with our combination of reason, imagination, inclination, passion, and will.

It is a disputed question whether Kant can be said to have taken either the mode of recognition or the main subject matter of morality to be anything displaying mutual dependence, any commons of the mind. His formulation of right action as acting on maxims one can will as laws in some system of second nature, acting as members of a kingdom of ends, seems to make community pretty central to morality, but it is at best unclear how much actual communing with others in any actual system of customs has to occur, according to Kant, for any single moral agent to find out what counts as such morally proper action, in some concrete situation. Kant usually writes as if moral deliberation goes on in a single head, or its noumenal analogue. And the respect one moral agent is to show any other seems to be more a matter of drawing away than of drawing close enough for dialogue and collective decision making. Nor do Kant's political recommendations (or rather his accommodations to the authoritarian culture in which he was writing) make him much of a hero of the democratic, or indeed of the republican, tradition. That moral reasoning should not be displayed by Kant as essentially interpersonal is odd, given that he took theoretical reason to be thoroughly dialogic: "For reason has no dictatorial authority; its verdict is always simply the agreement of free citizens, of whom each one must be permitted to express without let or hindrance, his [or her?] objections or even his veto" (*Critique of Pure Reason*, A739, B767). Still, even this fine proclamation's main point is to insist on a certain autonomy for each individual reasoner.

Those, like Hume, who did explicitly claim that an individual's judgment did not count as a moral one unless the individual judger had good and so suitably informed reason to expect other judges to concur, and who did take explicitly moral judgments to concern *mores*, not just a single person's perfection-

seeking endeavors, appealed to sentiment, not reason or will, as the source of moral judgment. Was this because they took there to be a commons of the mind with respect to passions and sentiments, more obviously than there was with respect to other mental capacities? There is a sense in which they did take a common human nature to guarantee common basic desires and a common repertoire of emotions evoked by a common set of causes, but this shared nature does not give a commons of the mind in the sense that I have been using that phrase. As Kant emphasized, having the same sorts of desires as others have can generate conflict, not any common feeling. "What my brother wants, that I want too" sets the stage for dispute, not for brotherhood or fellowship, especially when it is revenge on the other that each of us wants. Dispute, of course, is something that I can engage in only if, for some "us," "we" engage in it. Feelings of rivalry, envy, jealousy, enmity are indeed social emotions, in the sense that we need others, and others displaying the relevant complementary emotions, for such emotions to be even possibilities for us. Still, this sort of unsocial sociability seems too negative a basis for morality, if morality is to establish or endorse some sort of cooperative and nonviolent plan of coexistence. These other-dependent emotions may help to set the problem morality is supposed to solve, but they themselves can scarcely be enough to provide the solution.

Hume, of course, relies on our capacity for imaginative understanding and sympathetic sharing of each other's emotions, not just on a common human repertoire of emotions, as one prerequisite for the moral sentiment. His account of sympathy assumes that each passion begins, as it were, self-contained in a single person, but is capable of being duplicated in other persons, in some conditions, and needs to be thus duplicated, if its original owner is to sustain it for any length of time. So if my sister has the ambition to rule Milan, I may come to want her to succeed, and if no one sympathizes with her ambition, it will, in theory, wither in her. Hume's account of sympathetic passions makes them supportive ones, ones which duplicate not just the type and intentional object of another's

passion, as copycat passions or contagious panic fear do, but also duplicate the person-reference of the original passion, so that my sympathetic ambition will be not the desire that *I* rule Milan, but that my sister come to do so, possibly with some help from me.

This account seems to assume a sort of intrinsic individualism of passions, and then to supplement it with an account of a mechanism by which secondary passions, in the sense of ones that second someone else's passions, get added to the original set. The parallel account for reason would be if one supposed that each person comes to be a reasoner all by herself, then comes occasionally to echo others' reasonings, and sometimes to support them by affirming their arguments. Such an individualist version of reason, I have argued, is less plausible than a social view, which takes reasoning together to be the standard sort of reasoning, and the first sort experienced by each reasoner. The greater plausibility of the social view rests in large part on the skilled character of the activity of reasoning, and the standards of success that must be acknowledged, for it to count as reasoning. Similarly for intending—the close conceptual connection between intention, socially recognized competence, and accountability was the main support for the claim that there is, with respect to our capacity for intention, a commons of the mind. But with desiring, loving, hating, fearing, fuming with anger, rejoicing, and sorrowing, no skills and no standards of success seem to be involved. They seem too basic, too primitive, for this normative sort of account to make much sense. Of course we do criticize some loves, hates, fears, angers, joys, and sorrows as irrational or unintelligible, but, as Descartes put it, however depraved or unrealistic one acknowledges one's desires to be, they can be genuine desires, for all that. As Hume put it, passions are original existences, complete in themselves, and what he meant by that famous claim included the Cartesian point that they are not, for their very existence, like beliefs answerable to standards of truth and falsity. Nor are they, like intentions, answerable to standards of 'rectitude'. Should all our standards be shared standards, then this means that a person's

passions, insofar as they are original existences, can more truly be said to be all her own than can her reasonings and her intentions.

But this individual ownership of one's passions, and passions' status as "original existences," should not be understood to deny either some cultural influence on them or some responsibility for them. Hume, who says they are "original existences," and in well-known texts says they cannot be reasonable or unreasonable, thinks that they are the proper objects of moral evaluation, and is even willing to say that some cases of, say anger, are passions that a "reasonable" person would not feel. (His example here is anger at deserved punishment [*T*, 350].) Some anger "rises up to cruelty" (*T*, 605) and is therefore to be criticized; some angers are more criticizable than others, despite the fact that "when I am angry, I am actually possest with the passion" (*T*, 415). Not only are the particular passions felt by individuals the possible objects of moral evaluation, but for Hume passions, motives, and other "principles in the mind and temper" are its *main* objects, while actions, "external performances," are morally evaluated only as "signs" of the inner motives that produced the actions.

Hume shows some awareness of the fact that cultures present individuals with better and worse versions of the basic human passions, available for their cultivation. In the *History of England*, he frequently expresses horror at "barbaric" cultures where brutal forms of revenge were tolerated, and welcomes the more "civilised" and less cruel variants of official anger displayed by enlightened magistrates, where the desire for revenge that Aristotle takes to be part and parcel of anger gets sublimated into less hurtful forms. Hume keeps "a desire of the misery" (*T*, 367) of the person we are angry with as virtually anger's essence, but the "misery" we want for the one whom we perceive to have harmed us, and so are angry at, may range from the cruel revenges exacted by Bishop Odo on Queen Elgiva,[51] through the discomfort of one who suspects he is

51. See Hume's account of this in *History of England*, chap. 2.

satirized in a novel,[52] to the contrition of the one who begs
our pardon. As Myles Burnyeat has pointed out,[53] we today
are not restricted to Homeric anger, indeed few of us might
admit to ever feeling or wanting anything like what Homer
presents Achilles as feeling and wanting, when he was angry.
Centuries of Christian condemnation of returning evil for evil,
including such things as Butler's sermons on resentment and
on forgiveness, have effectively emasculated the desire that
most of us will admit to, when angry at anyone. Or perhaps
not just what Kant called the fact of Christianity[54] reformed
anger, but also commonsense reflection on, even anger at, the
endless replication of retaliatory strikes when anger is left in its
barbaric 'natural' Homeric form, what Butler[55] aptly termed

52. A recent book by Louise de Salvo has the title *Conceived with Malice: Literature as Revenge* (New York: Penguin Books, 1995). Philosophy teachers who keep up with the novels written by their colleagues and former students are familiar with this form of revenge.

53. Myles Burnyeat, "Anger and Revenge," a talk given to the University of Pittsburgh intrafaculty colloquium, October 1995. Burnyeat drew attention to the fact that the O.E.D. in 1885 defines anger simply as a "feeling against someone."

54. Immanuel Kant, *Religion Within the Limits of Reason Alone,* bk. 4, pt. 1, sec. 1, "The Christian Religion as a Natural Religion," where he writes that for the foundation of a universal visible church of the "true" moral religion to be founded, not merely the concepts of pure reason *(des reinen Vernunftbegriffs)* are needed, but also "ein Faktum." Earlier he had referred to the true moral religion of Christianity (as distinguished from any mere "esslesiastical faith" which demands acceptance of dogmas and imposes statutory rites and duties) as a matter of historical fact in his own time, *"wenn die wahre Religion einmal da ist"* ("General Observation" at the end of book 2). It should however be noted that Kant does not take this true religion to have given up the idea that its just God is an avenger of disobedience to His law. On the contrary, he goes to extraordinary lengths to show how, since it would be inappropriate to punish the reformed sinner for what his earlier unreformed will chose to do, yet unjust also to let it go unpunished, the punishment must lie in the pain and difficulty of the act of reform itself, which is to be *"als 'das Absterben alm alten Menschen' 'Kreuzigung des Fleisches' "* (book 2, first section, "Difficulties"). The need for something more than contrition, the need that it be a painful self-crucifying turn away from the wrong, is still seen to be there, in the offended "Moral Governor." The *"Geheimnis der Genugtuung"* is not that crucifixion is required as "satisfaction" to a God offended by human sin, but that one such crucifixion, and that of an innocent scapegoat, is enough. What is an "unerreichbares Geheimnis" is not the form of "satisfaction" demanded, but that one could take another's place as maker of this grisly payment for sin. ("General Observation" at end of third book.) So Kant's version of divine anger and vengeance within the limits of "blossen Vernunft" does not set a very good example, by Butler's standards, for human anger at offense. Compare Hume on divine punishment, in "Of the Immortality of the Soul": "Punishment according to *our* conceptions, should bear some proportion to the offence. Why then eternal punishment for the temporary offences of so frail a creature as man?"

55. Joseph Butler, sermon 9, "Upon Forgiveness of Injuries," in *The Works of Joseph Butler,* ed. W. E. Gladstone (Oxford: The Clarendon Press, 1897), vol. 2, p. 129.

the "long intercourse of ill offices" that revenge sets in motion. Parents know that small children's anger at offenders still takes the Homeric form, so it is only after parents have rubbed off such "rough corners" (*T*, 486) that the more civilized variants of anger become available to new members of a community. We have to be trained, in order to find apology adequate satisfaction of our (if Hume is right) innate desire for revenge (*T*, 439). And it is not at all clear that we all agree in condemning the desire to return unmistakable evil for perceived evil. Bosnia shows us that barbaric revenge is still alive and well today.

Hume has to spell out the requirement that the moral sentiment be one we expect others to share with us (in the sense of expecting them to share our approbation, when we approve of forgiveness, of making do with an apology, and to share our disapprobation when we condemn barbaric revenge), because the presumption, if moral judgments are based on taste and sentiment, would be for variation, not unanimity. *De gustibus non disputandum*. So it is *despite* the fact that morality is a matter of sentiment, of taking pleasure in certain human traits, not *because* it is, that the moral sentiment delivers verdicts that we expect others to concur with, such that we can enter into arguments about rightness and wrongness when others do not concur. Nor can agreement be hoped for just because the moral sentiment is based in extensive sympathy. Sympathy, however extensive, is liable to bias in favor of what is nearest and dearest to us, so a sympathy-based sentiment should be expected to show variation. And extensive sympathy will never itself decide between rival claimants to our decision in their favor—at most it can be a precondition of moral judgment, not itself the judge. Only because of Hume's requirement that the sympathy felt and the pleasure taken be felt and taken from an especially "general point of view," from which corrections for bias are made and a final verdict reached, does Humean morality come to be essentially shared. The commonality it has is an *intended and contrived* commonality, to some extent one that goes against the grain. It is a bit like many jury verdicts, where it

takes contrivance, time, and effort to get a verdict. Precisely because moral agreement is not easy, and is not automatic, given morality's passional sources, must the goal of such agreement be explicitly recognized, and fussed about. Rationalists might think that it went without saying that we could all reach agreeing moral judgments if we all used our reason. Sentimentalists could not let it go without saying.[56]

Rationalists of course did not necessarily achieve agreement in their moral judgments, even with other rationalists. The universality of moral reason was more a slogan than a reality, just as the moral consensus of the members of Hume's "party of humankind" is also more aim than achievement.[57] But it is in some ways easier to recognize that agreement is a moral task, not a God-or-Nature-given certainty, if one has a clear recognition that the roots of our moral disagreements are the very passions and partial sympathies that are the roots of morality itself, both of the problem it tries to solve and of its competing attempted solutions.

The hedonic passional roots of morality, on the Humean story, do however have some features that predispose us to a modest degree of harmony and agreement. If Hume is right about us, our tendency to have sympathy with another's feelings and opinions is one of our most basic tendencies, and this is interfered with only when special conditions encourage us to "compare" our well being with that of the other, and resent any inferiority. Even though this sympathy is biased in favor of

56. Some of them also saw a danger that reliance on reason might threaten rather than undergird morality, since the paradigm of practical reasoning can be seen as self-interested calculation. Rousseau writes in the *Discourse on Inequality,* "Reason is what engenders egocentrism, and reflection strengthens it. Reason is what turns man in upon himself. Reason is what separates him and moves him to say in secret, at the sight of a suffering man, 'Perish if you will; I am safe and sound.' . . . Savage man does not have this admirable talent, and for lack of wisdom and reason he is always seen thoughtlessly giving in to the first sentiment of humanity" (Jean-Jacques Rousseau, *Basic Political Writings,* trans. and ed. Donald A. Cress (Indianapolis, Ind.: Hackett Publishing, 1987).

57. I discuss Hume's treatment of apparent moral disagreement in "Moral Sentiments and the Difference They Make," *The Supplementary Volume of the Aristotelian Society,* ed. Jonathan Wolff (Proceedings of the Joint Session of the Aristotelian and Mind Societies, 1995).

those perceived to be more like us, or closest to us, it does establish some limited sharing of concerns. Is it just a contingent fact that we have a natural capacity for sympathy? And is it simply a contingent fact that there are some things we nearly all fear, nearly all resent, and nearly all enjoy? And that we mostly *do* regret our "infirmity" of calm purpose, our tendency to go for the closer rather than the greater good (*T*, 536)? On Hume's story, and I think on any plausible naturalistic story, no. Hume's own account of necessity might seem to make it difficult for him to recognize the sort of thing Anscombe calls an "Aristotelian necessity."[58] If "there is but one kind of necessity" (*T*, 171), and that kind includes "the necessity that makes two and two equal four," as well as fire to cause burns on any human flesh it touches, and our minds to be influenced by experience of "constant conjunctions," then is there any room left for the supposed "impossibility" (*T*, 474) of extirpating moral sentiments, or for the moral necessity that promises be kept, or for the psychological necessity that we have good not ill will towards those we love?

In a way Hume's very sweeping claims about necessity make it easy to bring in all sorts of things as necessities, and to some extent Hume encourages this. Although "abstractly consider'd," it is not necessary that love lead to good will rather than ill will towards the beloved (*T*, 368), Hume the empiricist and naturalist is certainly not committed to considering such matters only abstractly, and he is willing to speak of "absurdity" as threatening our emotional lives, should we not tend to agree in our valuations, and not be right in assuming that others are more likely to love us for the aspects of ourselves in which we take pride than for those that cause us shame. A certain "correspondence" in sentiments is required, if our normal ways of proceeding are to avoid absurdity. And why would we ever want to "acquire the love" of others, rather than their hate, if love reliably brought ill will in its train? Many of our "methods of

58. G. E. M. Anscombe, "Promising and Justice," in *Collected Philosophical Papers* (Oxford: Basil Blackwell, 1981), vol. 3, p. 18.

proceeding" would indeed be absurd, if nature had chosen to disassociate love from good will, or the causes of humility from those of hatred. This, for the naturalist, shows nothing about deep metaphysical necessities, any more than the fact that there is what we recognize as order in the physical universe shows that there must be a cosmic designer. For how would passionate beings who need others to second their evaluations, and need their cooperation, have persisted in existence, generation after generation, unless there *were* the correspondence Hume is pointing to? Any in whom the correspondence failed would be very disadvantaged for survival, mating, and child care, just as any who did *not* find order in the universe they are part of, and so were not tempted by the argument from design, would have a hard time managing in their environment, and so be in a sense defective.[59]

Hume speaks of our being guided by "a kind of *presensation;* which tells us what will operate on others by what we feel immediately in ourselves" (*T,* 332). Without such a fairly reliable presensation, and without our trust in it, we would be hopelessly at sea in our dealings with one another, having to treat each new person as a new self-contained species, with a nature all its own. However strong and well developed our individual reasoning powers, and even if reason were complete in each individual and not dependent on reasoning together (which, in any case, would be most unlikely to occur if our wishes and preferences were a mystery to each other), we would have very great difficulty predicting how any other would respond to any overture we might make. We do, in our dealings with members of any already familiar species, including our own, expect previously unencountered members to behave in the same general way, and show the same general fears, desires, and hesitations as its conspecifics.[60]

59. See Philippa Foot's 1994 Hart Lecture, "Does Moral Subjectivism Rest on a Mistake?" *Oxford Journal of Legal Studies* 15, no. 1: 1–14. I am also indebted, as Foot writes that she is, to Michael Thompson's "The Representation of Life," in *Virtues and Reasons,* ed. R. Hursthouse, G. Lawrence, and W. S. Quinn (Oxford: Oxford University Press, 1995).

60. Once when offering food to semitame squirrels, who were willing to approach close enough to take food from my hand, but otherwise cautious and as it were respectful towards me, I had the disconcerting experience of being treated by a very young and

We could not have a "species being," in Marx's sense, that is a typical way of responding to and selectively cooperating and competing with each other, had we not a human nature in Hume's sense, that is a fairly uniform range of desires and emotions.[61] Because it is roughly uniform, then it is not unreasonable of us to think that, subject to verification or correction by listening to what others *say* about how they feel, we can tell what will operate on others by what we feel immediately in our-

inexperienced squirrel as if I were either a tree, or its mother—I am not sure *what* it took me as, when, attacked by an older squirrel who wanted all the food, it leaped into my arms for sanctuary. Such unsquirrel-like behavior disconcerted me, precisely because there was a reliable squirrel norm of behavior, from which this case was a deviation. With our human conspecifics too, there are occasional deviations from the fairly dependable norm, the norm, for example, that young children do not cleave to strangers. I was almost as disconcerted as in the squirrel episode when recently, as I boarded the elevator in the Cathedral of Learning in the University of Pittsburgh, a child of ten or so, who was a member of a large group of school children about to begin a guided tour of Nationality Rooms on the first floor, detached himself from the group and said to me "Please, please, take me with you!" I was not quick enough to offer any response before the elevator closed and left, so I have no idea whether what he wanted was to get to the top of the building, or simply to escape the guided tour, or who knows what. But my jaw dropped, as it did when the baby squirrel landed in my bosom. That we are unprepared for such strange encounters shows us how prepared we are for the normal case, and how much we depend on the general truths we have learned about how squirrels and human beings typically behave.

61. We must, however, allow for cultural variations in what is deemed acceptable in the way of satisfaction and expression of these desires and emotions. Lust is fairly easily recognizable across cultural barriers, but some of its expressions can astound the traveler. It may not be disagreeable, as Hume says in his essay "Of Polygamy and Divorces," to consider what Hume terms "Asiatic manners" in these matters, in particular two of my educative encounters with men of Asia Minor, which I select from other interesting foreign encounters because of the Humean connection. On a visit to Istanbul, my husband and I acquired the company of a young bank worker met, suitably enough, in the palace seraglio. He insisted on accompanying us as a guide on our exploration of the city, claiming that he wanted to improve his English. He then seized any brief opportunity to manhandle me, on the staircases of Rumeli Hisar, behind statues in the archeological museum, etc., until we managed to shake him. The presence of an accompanying husband, it seemed, was no deterrent, perhaps even an added incentive. We encountered another Turk with interesting amorous enterprise towards foreigners when we shared a launch with some local high-school teachers from Antalya, to visit the ruins of Pharselis. The teachers dived and speared fish, which we grilled and ate for lunch on the beach. One of them, with some ceremony and eloquent eye language, passed me the eye of the largest fish, as the tastiest morsel. Politeness prevented me from refusing this unwelcome gift, but my acceptance may have meant more than I realized. For on the return journey this man proposed that he come the next afternoon to our beach hotel, and that I earlier dispatch my husband on a long swim out to sea. These encounters add to my appreciation of Hume's report, in the polygamy essay, of the observation of Mehemet Effendi, Turkish ambassador in France: "We Turks are great simpletons in comparison with the Christians. We are at the expense and trouble of keeping a seraglio, each in his own house: But you ease yourselves of this burden, and have your seraglio in your friends' houses."

selves. And because we do have a species being in Marx's sense, our human nature in Hume's sense shows the sort of correspondence or coordination in feelings which he, in the *Treatise,* took to be brute fortunate fact, albeit a fact that dictates what we count as virtues and as vices or defects.[62]

This "correspondence" to some extent holds for our indestructible moral feelings, as well as our simpler sorts of feelings, those that we may believe to have some analogues in other higher animals. We *do* suppose that our outrage at injustice, our horror at extreme cruelty, will be at least intelligible to others, and probably shared by most. Could we find no one to agree with us in finding some particular treatment outrageously unfair, no one to "second" our disapproval of, say, the navy officer who refused to lead women in combat, or the cadets who cheered when the first woman admitted to the Citadel in Charleston withdrew after one week, we would be nonplussed, and lose confidence in our judgment. There may well be only one just man, but not only one who recognizes his justice. But, as such cases demonstrate, we will not find anything like a consensus. The officer reportedly refused on what he saw to be *moral* conscientious grounds to lead women in combat, and the cadets saw themselves to have *a right* to single-sex training. The naval officer's biblical morality, he believed, forbade putting women into combat roles. And we do not expect him to be alone in his judgment on this issue. As far as I know he is not recorded as finding the same moral obnoxiousness in subjecting women to what their male officers subjected them to in the Tailhook affair, but that was a more traditional and time-honored role for women. Women traditionally could be, and often were, the attacked, but not the armed attackers. Occasional

62. Philippa Foot, in "Does Moral Subjectivism Rest on a Mistake?" takes Hume to be one of the mistaken subjectivists, but he can equally plausibly be seen to be in agreement with Foot's brand of naturalism in ethics. His demand that nothing count as a virtue unless it is the norm not the exception in human nature, a point he makes (*T* 483) while explaining what justice is and why it is a virtue, is in line with Foot's views. See my "Natural Virtues and Natural Vices," *Social Philosophy and Policy* 8, *Ethics, Politics, and Human Nature* (autumn 1990): 24–34.

anomalous heroines such as a Holofernes-beheading Judith may be tolerable, on biblical morality, but not large numbers of uniformed women doing the official killing.

Our shared human nature does not guarantee our agreement on moral matters, especially on what counts as injustice. But our shared human nature guarantees that we will think in terms such as "violation of human rights," "injustice," "inhumanity," "breaking faith," "cruelty," and condemn what we think fits these categories, even when we do not all agree on what counts as cases of them. We cannot be expected always to agree on what is unjust, or cruel. For one reason, our species-nature, and its historical and cultural variations, including our differing customs of moral upbringing, plays a dominant role in the genesis of our moral feelings. Our moral feelings initially are the product of the very mores that, at a later stage, they evaluate and sometimes condemn. But the condemnation is usually partial, not a complete repudiation of our moral heritage.

This cultural dependence is shown also in such simpler matters as our taste in foods. That some human beings enjoy eating dogflesh and some are disgusted at the thought, that horseflesh is by some prized as a delicacy and by others rejected in indignation (if offered *as* horsemeat, rather than just as goulash or stew), that some can eat and enjoy pork and others are sickened by its smell, all these are obviously cultural variations, matters of habituation, not of innate differences. But the cultural variation of moral reaction is more interesting than this, and less predictable in its manifestations. For we do not simply continue in the moral ways we were trained in our youth to go in. We are much more likely to depart from those ways than we are from our learned eating habits of acceptance and rejection, although moral reflection can alter these too, as the rise of vegetarianism on moral grounds makes evident. This is, of course, because moral ways are ways of judging behavior, and so have intrinsic potential to be turned on themselves. They are not always found to bear their own survey. For any one person who is true to the morality she was trained in, in childhood, there will be

at least one who has rebelled against some parts of it, become
critical of them, and moved on to other supposedly superior
standards of judgment. As Hume began but certainly did not
end with the Calvinist version of the "Whole Duty of Man,"[63]
so most of us end not quite where we began. And yet we are
not content just to agree to differ with our parents and grand-
parents who trained us—typically we do want to retain "the
love and approbation" of that small segment of mankind who
trained us in the ways from which we have departed. As Hume
well knew, and went out of his way to emphasize, "we are most
uneasy under the contempt of persons who are both related to
us by blood and contiguous in place" (*T*, 322). If we fail to
convert our elders to our more enlightened ways, we will likely
place ourselves at a distance from them. Yet the young Hume
returned from France to his pious mother at Ninewells, and the
older Hume could not fully break with his minister friends in
Edinburgh. Distancing is a temporary and unsatisfactory mea-
sure. The admittedly difficult aim has to be moral agreement,
or, at the very least, some prospect of it, as the outcome of
"conversing together on reasonable terms."

The hope of agreement is not vain, if the disagreeing parties
to some extent share a common moral vocabulary, some com-
mon sources for their moral ideas and feelings, and a willingness
to listen to each other. No moral innovation, however radical,
sprang out of nowhere, and much moral reform comes about
by internal criticism of an older moral order. Some comes from

63. *The Whole Duty of Man: Necessary for all Families* (anon., printed by R. Norton
for Robert Pawler, at the Sign of the Bible, Chancery Lane, London, 1684) had
included, in its list of breaches of duty, various breaches of the duty of humility and
such other sins as "eating too much," "heightening of lust by pampering the body,"
"not labouring to subdue it by Fasting, and other Severities," and "not assigning any
Set or Solemn time for Humiliation and Confession, or too seldom." Hume is opposing
not merely the "monks" when he demotes "Celibacy, fasting penance, mortification,
self denial, humility, silence, solitude" to vices, but the Calvinists who had preached to
him, and the other Protestant divines whose tracts he had been given as a child to help
him learn to recognize vice. But there are very many of the duties listed in *The Whole
Duty of Man* that Hume includes in his catalogue, and that repeat those listed in
Cicero's *Offices*, which he told Hutcheson was his preferred source book on morals.
"Not loving peace," and "going to law on slight occasion," as well as theft, ingratitude,
lying, malice, and oppression are all condemned in the *Whole Duty*, and Hume would
have little quarrel with these disapprobations.

comparing and contrasting different cultures—from moral travel, as it were.[64] But the capability for seeing internal tensions and inconsistencies within, say, a Christian but slave-owning culture, or a culture which regularly intones its belief that all human persons are created equal, yet denies equal basic rights to the female half of its population, is never isolated in solitary individuals. What one reformer sees or hears (since often it is listening to victims that sparks the reformist flame), is there to see and hear, and can be seen and heard by others. The pull of piety to the old ways, the faith of the fathers, will always be strongly felt by some, and reasonably felt, since those ways are the departure point for whatever new path is taken, and something in the old values will usually be what makes possible the very criticisms that the moral reformer makes. Reform, not revolution, is the normal mode of moral change.

It is to be expected that some will resist any change, and that some innovators will be unwilling to acknowledge their debts to the culture they hope to reform. Some will be more unwilling than others to enter imaginatively or experimentally into the mores of other cultures, to listen to their spokespersons, to do any moral travel before settling in some voluntarily accepted homeland, some set of values they are content to live by. But as we all first learned from others what is deemed morally acceptable, and what is not, so we all need others to test, confirm, challenge, and amend any moral innovations we may ourselves propose along the way. It is vital that our moral evaluations be done in conversation in which the listening is as important as the speaking, rather than in soliloquy accompanied by overconfidence in one's ability to imagine oneself in others' shoes. It is just as vital that these evaluative conversations be carried out on reasonable terms, as regards the chance to speak and be listened to. It is only reasonable that those who have only recently been included should get more of the speaking time than those who have long held the floor, but equally reasonable that the time

64. I have explored the value of such travel in "The Virtues of Resident Alienation," *Nomos* 34, *Virtue* (New York University Press, 1992), pp. 291–308.

during which this reasonable reverse discrimination is practiced be limited, and yield in due time to something more like equal time. As far as women's voices in the moral conversation in this culture and this profession goes, I think that we still need to listen considerably longer to battered wives than to battering husbands, to the victims rather than the perpetrators and condoners of sexual harassment. But not only women are attentive to, and speak on behalf of,[65] the victims of these social ills. We are, I think, approaching the point when, as women philosophers, we can be content with, indeed rejoice in, equal terms in the philosophical conversation. Women in general are now full participants in the moral conversation in our culture. But there are particular groups, such as African Americans, Hispanic Americans, Native Americans, Asian Americans, resident aliens, and especially women members of all these groups, from whom we have not yet heard nearly enough in either the philosophical or the public debate. If the moral and the moral-philosophical conversation is to continue in the most reasonable way, extra time will be given to voices from such groups.

Moral evaluation of individual behavior, of individual character, of social practices, and of what Hume called "national characters," draws on almost all our collective human resources, and so is the most complex of our collective capacities, needing input from all groups among us. It presupposes the capacity for simpler sorts of preferences and evaluations, those based simply on shared pleasure and shared tastes and desires, such as the normal human preference for firm rather than mushy, tasty rather than bland, apples,[66] and for smiling rather than frowning human faces. It presupposes the imaginative capacity to put oneself in others' places, and the willingness to be corrected by those in such places when one's imaginative version of what it is like to be in them turns out to be fanciful. It presupposes the reason that can trace consequences and discern inconsistencies,

65. The right to speak on behalf of some group of which one is not a member does, of course, have to be earned. This point is forcefully made by Laurence Thomas in "Moral Deference," *The Philosophical Forum* 34, nos. 1–3 (fall–spring 1992–93): 233–50.

66. See J. O. Urmson, "On Grading," *Mind* 60 (1950): 152.

the memory that can learn from past experience, the trust and trustworthiness that enables learning from others' testimony and recorded experience, and it presupposes the capacity to take part in our practices of calling for and giving an account of what we are doing. I see no good reason to single out one of these many premoral roots of morality as more fundamental than the others, so tend to find any account of morality that plays up one of them at the expense of all the others an over-simplified account. Many such oversimplified accounts can char-itably be construed as corrections of earlier simplifications in a different direction—for Shaftesbury or Hume to stress senti-ment, pleasure, and sympathy was understandable, given that people like Clarke were overemphasizing an intellectualist ver-sion of reason.[67] For Kant to stress rational will, and the capac-ity for self-command, was also understandable, given that Wolff was overemphasizing intellect,[68] and that Hume might be read as underemphasizing will. But a study of the history of ethics, as well as reflection on what we actually do expect of moral evalua-tors, should make us suspicious of any account of our moral capacities that leaves out what any moral theorist has ever said was morality's main source (and I include those who saw reli-gion as its source). The history of ethics serves as a virtual com-mons of the moral philosopher's mind. Single voices there respond to and contradict other single voices, and each voice has some partial truth to tell.

Still, it does seem to me that those philosophers who took a broad rather than a narrow view of *what* moral evaluation eval-uates, and those who had inclusive rather than exclusive accounts of what capacities are exercised in this evaluation, speak a little more truth than the others. And those who made

67. Clarke's overemphasis may be excusable if he was, as Jerome B. Schneewind suggests in "Voluntarism and the Foundations of Ethics," (Presidential Address to the Eastern Division of the American Philosophical Association, December 1995), reacting against extreme forms of voluntariam in ethics, which saw God's arbitrary will as the source of moral norms, and deference to that powerful will as the whole of virtue.

68. According to Schneewind, in his Presidential Address, we can also see Kant's emphasis on rational will as an emphasis on *rational* will, a correction of Crusius as much as of Wolff. My own understanding of Kant's relation to his philosophical prede-cessors owes much to Schneewind's two-volume anthology, *Moral Philosophy, from Montaigne to Kant* (Cambridge: Cambridge University Press, 1990).

reflexivity the special feature that transforms the exercise of any capacity, or any combination of capacities, from a premoral into a moral manifestation of our mental powers surely got something important right. This would mean that, insofar as morality is concerned with trust, or with accountability for our actions, or with recognition of our beauties or uglinesses of individual character, it will itself exhibit some meta-trust and meta-distrust, meta-accountability, and meta-taste in characters—as moral evaluators we will show trust and distrust in our ways of encouraging or discouraging particular forms of trust; we will assume accountability for our procedures of holding to account and our procedures of training people to be accountable; we will supervise the supervisors and keep scores on the scorekeepers; we will consider the beauty or ugliness of our recognitions of relative attractiveness in character; and so on. We will consider whether our customs of encouraging and discouraging trust, our procedures of supervising and holding to account, of teaching accountability, and of recognizing character, themselves pass muster.

One of the attractions of the Humean view that moral approbation is a reflective variant of pleasure is the broad scope therefore granted to that approbation. We take pleasure or displeasure in an enormous range of things,[69] and even when we narrow down to the pleasure we take in one another as persons, as possessors of what Hume calls "characters," there is still a large range—we approve or disapprove both of individual and of group character, both of thoughtless habits and of calculated policy, both of action and of reaction. Our evaluative reactions to all these aspects of ourselves, both as individuals and in our group formations, help to determine our friendships, our elective affinities, our emigrations and immigrations, the whole range of our loves and hates. For these to be *moral* evaluations, an extra step has to be taken, beyond that needed for stable

69. As animals, we are just as omnivorous when pleasure-seeking as when curiosity-prone or food-seeking. And the very fact of omnivorousness gives us a choice that less omnivorous animals do not have, when it comes to restriction, or indulging preferences, reflective or otherwise, for some forms of pleasure over others, some sorts of knowledge over others, some eating habits over others.

mutually intelligible likes and dislikes of persons and communities. Hume calls it the taking up of an especially general point of view, from which all these lower-level habits, likings, dislikings, policies towards people, sets of rights and duties, habits of trusting and distrusting, come into view, and can be impartially surveyed, by surveyors who converse together on reasonable terms with one another about the judgments they are forming, and about the particular sort of "agreeability" or "utility" they find in the customs that get their approval. And of course these reasonings, sentiments, and procedures by which the moral judging gets done themselves implicitly ask for some seal of approval; they too should be able to "bear their own survey."

Hume calls it a "sentiment" that pronounces the final moral judgment, if indeed anything counts as final in this process of judging, including the judging of both judges and standards of judgment, at indefinitely many levels. But there are so many constraints operating on this supposed sentiment which yields moral verdicts that it is impossible to say whether it is best called a feeling, a conclusion of evaluative reason, or even a determination of the will. Unless the proper point of view is intentionally taken up, whatever is seen will not count as *moral* vision, nor any judgment guided by it count as moral judgment. So intention plays its part in yielding the judgment, as well as frequently being the object of that judgment. The process leading up to moral judgment often requires "that much reasoning should precede, that nice distinctions be drawn, complicated relations examined, and general facts fixed and ascertained" (*E*, 173), so reasoning is definitely incorporated in moral reflection, on Hume's version of it. Calling it a "sentiment" that pronounces the final verdict (when anything does, since often moral reflection is inconclusive) at least acknowledges the mixed cognitive-conative-affective nature of the whole operation, since sentiments are anything but raw feels—they are very definitely culturally "cooked" ones, and tradition, reason, sympathy, and controlled reflection do the cooking.

There is no particular point in disputing whether the reflexivity characteristic of moral deliberation derives from the poten-

tial reflexivity of reason, or intention, or pleasure and passion, since all of these can display reflexivity, and, when they do, transform, by the act of reflection, what is reflected upon. Whether the original reasoning, intention, pleasure, or displeasure gets endorsed or negatively criticized by its own survey, it typically will not survive unchanged. If endorsed, it will be not merely strengthened but altered in quality; if rejected it will either wither away, or, if it does not, it will be different—it will survive as diffident reasoning, as merely half-hearted intention (or, alternatively, as defiant will), as guilty or self-disgusted pleasure, or as anger angry at its own occurrence, and so as transfigured anger. What Kant called the critical or disciplinary vocation of reason is not a vocation really restricted to "reason alone," as a purely cognitive capacity. The germs of it are found also in our affective and conative capacities, with their potential for reflexivity and self-criticism. It may indeed be significant that Kant, after proclaiming this endlessly critical and self-critical duty of reason, and its need for "dialectical debate," moves smoothly on to talk of the *"Gesinnungen"* (which can be translated "sentiments") that are expressed, sincerely or insincerely, in such debate. There is no significant disagreement between a philosopher (Kant?) who takes moral reflection to employ a practical version of a social self-critical as well as inclination-criticizing reflective "reason," contributions to whose dialectical debate can be termed expression of "sentiments," and one, such as I take Hume in his philosophical writings to have been, who takes moral reflection to consist in a conversation on reasonable terms between persons who have exercised their capacity for extensive sympathy as well as for reasoning, and who have taken up a point of view designed to give the reasonable hope of agreement on "standards of merit and demerit" in human characters, a conversation whose endpoint, when one is reached on a particular matter, is termed an expression of "sentiment." There may indeed be important moral disagreements between Hume and Kant on such matters as suicide, and the desirability of various degrees of control of natural inclinations, but there does not seem to be a very large substan-

tive difference of opinion about the process that counts as moral reflection. At most their disagreement there is one of where the emphasis needs to be put, and that may well be a matter where, as each would agree, the best place for the emphasis (on sentiment, on reason, on will) depends on the stage of debate. At the stage we are at, the reason versus sentiment disagreement is less pressing than, say, the disagreement over assisted suicide and abortion. If philosophers who more or less agreed on method can so sharply disagree on actual moral issues, as Hume and Kant do on suicide, then our chances of reaching agreement on issues, when we do not all agree about method, seem very slight. Attempts such as that of Rawls to separate out areas where agreement is more likely (consensus about a conception of justice, about a just constitution, about what comprehensive moral views are reasonable, about which of them are more reasonable) can be seen to be continuations of Hume's project of aiming at a conversation on reasonable terms, and of the dialectical debate of Kant's critical reason, sobered by the thought that it may be only by agreeing to restrict our agenda that we have any hope of agreement.

Alas, one of the most recalcitrant disagreements may be on how precisely we should limit the agenda of different forums of reason, and about what we should do in the face of this disagreement. Kant and Hume may have agreed more easily at the higher methodological moral levels than at lower levels where concrete moral issues are addressed, or at least have arrived at reasonable terms on which their philosophical disagreements could be discussed, but it is not so clear that those with the comprehensive views of the "moral majority," or of the Roman Catholic minority,[70] can agree with Rawls and other liberals about the distinction between agreement on the justice that is the first virtue of institutions in the basic structure of our society, and agreement on how it is right for individuals to live their lives. Rawls writes that "Political liberalism counts many familiar

70. See Philip Quinn's 1995 Presidential Address to the Central Division of the APA, "Political Liberalisms and their Exclusions of the Religious," *Proceedings and Addresses of the American Philosophical Association* 60, no. 2 (November 1995): 35–56.

and traditional doctrines—religious, philosophical, and moral—
as reasonable, even though we could not seriously entertain
them for ourselves, when we think they give excessive weight to
some values and fail to allow for the significance of others." In a
footnote he adds that doctrines that we, as members of some
part of the background culture, regard as unreasonable or
untrue we may correctly see as reasonable, for the purposes of
political liberalism.[71] At a later point he considers "the troubled
question of abortion," and finds that political values, as political
liberalism sees them, support the right to first trimester abor-
tion, that indeed it can be "cruel and oppressive" to deny it or
limit it to cases of pregnancy resulting from rape or incest.[72]
Suppose that someone, in her comprehensive moral view, finds
that abortion is wrong, indeed is the grave wrong of murder.
Can she possibly still be a political liberal, and believe that it is
reasonable for the state to allow it, and that comprehensive
moral views allowing it are, as inputs into an overlapping con-
sensus, reasonable?[73] Or would her comprehensive moral doc-
trine necessarily be seen by the liberal to "run afoul of public
reason," so have to count as unreasonable? It seems to be at
least in part a *moral* question whether a person could with
integrity maintain "I believe all abortion to be the grave wrong
of murder, a violation of the rights of the fetus, but I will
defend your constitutional right to choose it." It is one thing to
disagree utterly with what a person says and yet defend their
right to say it, another to condemn what they do as murder, yet
defend their right to do it. Whether we should properly com-
partmentalize our moral reasoning into the "political" and the
"comprehensive" is itself a moral matter, and it is not obvious
to everyone that, to have a conversation on reasonable terms
about this matter, the first step should be to restrict our agenda.

71. John Rawls, *Political Liberalism*, pp. 59–60, n. 13 on p. 60.
72. Ibid., p. 243, n. 32.
73. The woman who was "Roe," in Roe v. Wade, seems to be at present trying to
combine the view that abortion, including the abortion she had wanted, is wrong (so
working with right-to-life groups to dissuade other women from abortion), with the
view that the law should leave the choice to individual women.

Kant writes (of reason, not of moral let alone political reason) that, should reason "limit freedom of criticism by any prohibitions, it must harm itself. . . . Nothing is so sacred, that it may be exempted from this searching examination" (*Critique of Pure Reason*, A739, B767). Kant adds that this open-ended examination by reason should not be seen as threatening, since the examiners are not powerful judges but merely fellow citizens, fellow reasoners. Should our reflection about the proper relation between agenda-restricted political decision making, concerned with settling how we will coerce each other, and more open-ended moral reasoning[74] itself be restricted, or is it more reasonable to hold nothing, including liberalism, sacred? We must think beyond the restrictions of political reason if we are to reason about how exactly the limits of the political should be drawn. Our hopes of agreeing about this seem at present as faint as our hopes of agreeing about suicide or abortion. Moral reflection, as a social capacity, is still in its infancy, with many rough corners still to be rubbed smooth. A commons of the mind is by no means assured, where morality and political morality is concerned. Yet we cannot renounce the project of trying to establish such a commons. Patience, faith, and trust, not knowledge and full assurance, are needed if moral reflection is to perpetuate itself, while still holding fast to its goal of moral agreement.

74. Rawls speaks of "comprehensive views," but open-ended critical moral reasoning denies itself the comfort of thinking that it has ever answered *all* questions, so the comprehensiveness of any view can at best extend to the questions it raises, not to the presumed finality of its answers.

Appendix I:
Two Views of Reason and Revelation

In lecture 1 a wide conception of reason and of reasoning was defended. But of course no conception would be acceptable that included anything whatever that it pleased any person for any purpose to call the work of "reason."

Traditionally reason has been contrasted with revelation, the natural light with the supernatural light, and some of the most interesting episodes in modern philosophy occur when philosophers, living in religious cultures, tried to place their own thinking in its context within such cultures. Descartes when he tries to give an account of transubstantiation within the limits of reason alone, Kant when he does the same for the crucifixion and redemption, struggle to retrieve, for a rational faith, doctrines that their readers were predisposed to believe, given their Christian culture and upbringing. Rather than look at these two famous century-and-a-half-apart attempts to extend the natural light to cover what had been attributed to a supernatural light, or revelation, I shall look rather at two seventeenth-century near-contemporaries who addressed the problem of what to say about revelation, given that their own trust was in reason. I shall look at Hobbes's and Spinoza's attitudes to the Bible, that common source of revealed truth to Hobbes's more or less Anglican native culture, to Spinoza's original Jewish community, and to the Calvinist Christian community in which Spinoza lived once expelled from the Amsterdam Jewish community. For both these believers in reason rightly saw that *one* task

of reason is to address the question of trust in what is revealed in what are taken to be sacred scriptures. They shared the same Holy Writ, yet their attitude to it differs instructively.

Hobbes, in part 3 of *Leviathan* (1651), "Of a Christian Commonwealth," strives mightily to demythologize biblical teachings, such as the promise of eternal life and the threat of eternal damnation, to make them compatible with his materialism and with what he saw to be the needs of any functioning commonwealth. He tried to show how Christianity might, in some guise, be incorporated into that manmade "mortal God," Leviathan. He sees his task as relating the "Propheticall Word of God" to "the Naturall Word of God," that is to say, to reason. And this is no mean task, if the former appears to teach things that threaten the health of the commonwealth founded on the principles established by the latter.

> The maintenance of Civill Society, depending on Justice, and Justice on the Power of Life and Death, and other lesse Rewards and Punishments, residing in them that have the Sovereignty of the Common-wealth; It is impossible a Common-wealth should stand, where any other than the Sovereign, hath the power of giving greater rewards than Life; and of inflicting greater punishments than Death. Now seeing *Eternall life* is a greater reward than the life present; and *Eternall torment* a greater punishment than the death of Nature; It is a thing worthy to be well considered, of all men that desire (by obeying Authority) to avoid the calamities of Confusion and Civill war, what is meant in holy Scripture, by *Life Eternall,* and *Torment Eternall*. (*Leviathan,* start of chap. 38)

Hobbes begins part 3, "Of a Christian Commonwealth," by picking up from the last chapter of part 2, "Of Commonwealth," a chapter entitled "Of the Kingdom of God by Nature." This had established the tenets of natural religion, namely an omnipotent God, whose attributes are either the negative ones "Infinite, Eternall, Incomprehensible," or superlatives such as "Most High," "Most Great," or indefinites such as "Good, Just, Holy, Creator," whose laws are the "Laws of Nature," dependent on a divine will (understood not as "Rationall Appetite" but as the "Power by which he effecteth

everything"). Obedience to these laws is "the greatest worship," binding on us not in gratitude for our creation by God but solely "from his Irresistible Power." Other forms of worship are to be whatever the civil sovereign ordains as public worship, or allows as private worship, as long as that is not a natural sign of "Contumely." In part 3 he considers what needs to be added to this natural religion to entitle it to be called the Christian religion. His first point is that although, in addition to the "Naturall Word of God," which he has been articulating up till now in *Leviathan,* there is also the "Propheticall" or revealed Word, which adds to what reason alone could have established, natural reason is still to be in a sense sovereign, in that nothing that is contrary to it is to be admitted.

> We are not to renounce our Senses and Experience; nor (that which is the undoubted Word of God) our naturall Reason. For they are talents which he hath put in our hands to negotiate, till the coming again of our blessed Saviour, and therefore not to be folded up in the Napkin of an Implicate Faith, but employed in the purchase of Justice, Peace, and true Religion. (*Leviathan,* chap. 32, second paragraph)

Should some part of the revealed word, or some passage in "holy Scripture," appear to go against natural reason, that is to be put down either to "our unskilfull Interpretation or erroneous Ratiocination."

And so Hobbes launches himself into "skilfull Interpretation" consonant with his version of right reason, with some fascinating results. His interpretation is made fully consonant not just with materialism but with that fundamental corollary of right reason that we must obey the civil sovereign, not merely by his claim that we do not have to disobey any biblical divine command in order to obey the civil sovereign, but also by the occasional interpolation of qualifiers on his own interpretation, such as the one he adds to his interpretation of Adam's prelapsarian state: "with submission neverthelesse, both in this and in all questions, whereof the determination dependeth on the Scriptures, to the interpretation of the Bible

authorised by the Commonwealth whose subject I am" (*Leviathan,* chap. 38). There are no arguments for freedom of speech or worship included in Hobbes's ratiocination, at most a reminder that faith is "internal and invisible," so not able to be policed, whereas "profession with the tongue is but an external thing," and a reminder of the license that Elisha granted Naaman, not to put himself in danger by avowing a faith prohibited by his infidel sovereign (*Leviathan,* chaps. 42 and 43). One cannot but marvel at Hobbes's ingenuity as he argues for the lack of biblical warrant, and sheer impossibility, of such things as bottomless pits and eternal torments, for the postponement both of paradise and of the punishment ("second death") of the damned until after the second coming and the resurrection of the dead, for the realization that the Kingdom of Christ is not of this world, so that there can be no competition between the sovereignty of the civil sovereign here and now and Christ's sovereignty after the second coming, for the claim that if that future kingdom is literally anywhere it must be in Jerusalem, while Hell, where the damneds' second death will occur, will be the nearby city dump, Gehenna, where fire burns garbage, filth, and carrion (*Leviathan,* chap. 31). But is this clever reading of the biblical texts really reasoning, subjecting what purports to be revelation to right reasoning?

Hobbes had in *Leviathan* chapter 8 distinguished the intellectual virtue of prudence from "that Crooked wisdom that is called Craft," a perversion of reason that he takes to involve dishonesty, and to be motivated by "Fear or Want." He also notes a variant of false prudence "which the Latines call *Versutia* (translated into English *shifting),* which is putting off a present danger or incommodity by engaging in a greater." There seems to be something a bit crooked about Hobbes's treatment of the Bible, and a shifting of the author's risk from the present danger of offending his Christian sovereign to the greater risk of being seen by posterity to have done some fancy but essentially dishonest intellectual footwork in *Leviathan* 3. Or are we to

read it as a joke, subverting the claimed authority of scripture by the sheer hilarity of his materialist and absolutist scriptural exegesis? Is this a case where exegesis damns, rather than saves?[75]

His contemporaries were not amused by it. As Samuel I. Mintz, in *The Hunting of Leviathan*,[76] informs us, the first attack on *Leviathan* came from a theologian outraged at Hobbes's version of Christianity. Alexander Ross, in *Leviathan drawn out with a Hook, or Animadversions Upon Mr. Hobbs, his Leviathan* (London, 1653) calls him Anthropomorphist, Sabellian, Nestorian, Sadducean, Arabian, Tacian, Manichean, Mohammedan, Cerinthian, Tertullianist, Audean, Montanist, Aetian, Priscillianist, Lucerifean, Originist, Socinian, and Jew. We need not inquire what exactly all these heresies were supposed to be, to get the point that Hobbes's version of revealed Christian truth was immediately perceived as wildly unorthodox. So, as "craft," *Leviathan* part 3 was not too successful. Some preachers took up Hobbes's denial of eternal torment and envisaged his impious soul in a more orthodox hell, "the smoke of his Torment ascending for ever and ever." Few seem to have been amused. His more serious critics concentrated on the heresy, committed earlier than part 3, of denying authority to any except the civil sovereign, ignoring the details of Hobbes's materialist theology, perhaps sensing that to actually take up and criticize such unorthodox Hobbesian interpretations as that the trinity consists of Moses, Jesus, and the Apostles (chap. 42), that the authority of the Ten Commandments as law depended on the fact that "Moses, and Aaron and the succeeding High Priests were the Civill sovereigns" (chap. 42), that a Christian in a commonwealth whose sovereign is not Christian may perform whatever (nonobscene) form of religious worship the sovereign commands, as long as he has the true

75. I am indebted, for this pun, to Laura Ruetsche, a chapter of whose Ph.D. dissertation (University of Pittsburgh, 1995), "On the Verge of Collapse: Modal Interpretations of Quantum Mechanics," has the title "Exegesis Saves."

76. Samuel I. Mintz, *The Hunting of Leviathan* (New York: Cambridge University Press, 1962), pp. 55–56.

Christian faith in his heart (chap. 43), and so on, would be to
make biblical exegesis even more of a laughingstock than
Hobbes had already made it, either inadvertently or by design.

If Hobbes was, as Mintz makes him out to be, quite serious
in his materialist rendering of a version of the Christian revela-
tion that, while it goes beyond natural reason, does not offend
against it, then we can query whether this sort of taking up of
religious doctrines that happen to lie in one's cultural path, this
making the best one can of them, really is the work of reason,
especially when one realizes that, had one been born into a dif-
ferent religious culture, say a Catholic or a Muslim one, this
sort of work would have gone into vindicating a different set of
dogmas, into showing that they too can be a religion within the
limits of reason alone. If Hobbes in England can defend the
articles of the Anglican faith as reasonable, Cardinal Bellarmine
can do the same for Catholicism, and some Turk can do the
same for the Muslim faith. When the tenets of these faiths con-
tradict each other, then in religious wars between Protestants
and Catholics, or Christians and Muslims, not only can each
claim equally plausibly that God is on their side, but that reason
also is on their side. Hobbes of course does not claim that rea-
son does any more than *allow* his version of Christianity—he
does not claim that it is *more* reasonable than any other religion
except those Roman Catholic and Calvinist versions of Chris-
tianity that in *Leviathan* part 4 he designates "the Kingdome of
Darknesse." As Clarendon asked,[77] what would he have done if
born into a culture in which the Koran, not the Bible, were the
local Holy Writ? He admits, in the conclusion of *Leviathan*,
that his version of what the Bible says is "new wine," not even
in the old bottles but in a "new cask," and some ingenious
philosophical Muslim could doubtless do the same sort of
replenishing and recasking for the Koran. This would mean that
in any conflict between the defenders of rival versions of the
one true faith, possibly with rival holy writs, the sort of "reason-

77. Edward Hyde, Earl of Clarendon, *A Brief Survey of the Dangerous and Perni-
cious errors of Church and state in Mr. Hobbes's Book entitled Leviathan* (Oxford: printed
at the Theatre).

ing" that Hobbes employs in *Leviathan* part 3 can serve as a lackey to militant faiths. Hobbes surely did not intend this—he boasts that "there is nothing in this whole Discourse . . . as far as I can perceive, contrary either to the Word of God, or to good Manners, or tending to the disturbance of the Publique Tranquillity" (*Leviathan,* conclusion). But the new wine concerning that part of the "Word of God" which is by revelation, rather than by unaided reason, is not so clearly without threat to the public tranquility. Reason in the service of rival militant religions is not right, but crooked reason. Or, rather, it is either such "erroneous Ratiocination" or else "unskilful Interpretation."

Spinoza, faced in his culture with the same Holy Writ that Hobbes took on, is in his interpretation much more skillful in avoiding serving any militant faith. He is much more selective about which parts of the Bible to retrieve and endorse with the stamp of natural reason's permission. In his *Tractatus Theologico-Politicus* (1670, hereafter *TTP),* which incurred the same outcry from contemporaries as had Hobbes's *Leviathan* twenty years earlier, and indeed came to be bracketed with it, Spinoza follows Hobbes in many ways—in his critical attitude to the question of the authorship, dating, and canonization of biblical books, in his deflationary treatment of prophecy and of miracles, in his reservations about the sense that can be given to talk of the will or choice of God, and in his views about the relation of special revelation to reason, or the natural light. (Spinoza writes in *TTP* chap. 1 that natural knowledge is divine revelation available to all people who use their reason, while prophecy is revelation through visions given only to a few people, who need some special sign in order to trust such visions or imaginings. In the second chapter he writes: "In this respect, therefore, prophecy is inferior to natural knowledge, which requires no sign, but involves certainty of its own nature.")[78] But where Hobbes gives us his cleaned-up version of the trinity, the fall, the atonement, salvation, and the punishment of the damned,

78. Translations from *TTP* by Edwin Curley, as given in *A Spinoza Reader* (Princeton, N.J.: Princeton University Press, 1994).

Spinoza avoids specifically Christian dogmas altogether, and as for Old Testament teachings such as God's covenant with Abraham, God's appearing to Moses but not face to face, the Jews being God's chosen people, he treats all such scriptural teachings as "written only *ad hominem*," suitable encouragements to primitive and unenlightened people, "accustomed to the superstitions of the Egyptians, unsophisticated, and worn out by the most wretched bondage." Moses taught them, Spinoza writes, "in the same way parents customarily do children who are lacking in all reason."

So none of the doctrines which are distinctive to Judaism, or to Christianity, are among those that Spinoza retrieves from the Bible as more than passing *ad hominem* teachings, suitable at best for the oppressed, the ignorant, and the childlike. The only teachings which are not thus explained away are the claim that one omnipotent God exists, who alone is to be worshipped, and the moral teaching that "salvation" or blessedness lies in loving one's neighbor as oneself.

Spinoza is very clear about the fact that disputes over the more obscure teaching of the Bible have led those engaged in such disputes to pervert the moral religion it teaches, "so that religion consists not in loving kindness, but in spreading disagreement among men, and in propagating the most bitter hatred, which they shield under the false name of divine zeal and passionate enthusiasm" (*TTP*, chap. 7, sec. 4). He agrees with Hobbes that one should take from the Bible only "what is most universal, what is the basis and foundation of the whole Scripture" (chap. 7, sec. 27). (Compare Hobbes at the end of *Leviathan*, chapter 43: "I have endeavoured to avoid such texts as are of obscure, or controverted Interpretation; and to alledge none, but in such sense as is more plain, and agreeable to the harmony and scope of the whole Bible.") Hobbes identified as 'plain' doctrines many whose interpretation is controverted between Christian sects, in particular between Protestant and Catholic, and doctrines that distinguish Christianity from other monotheistic religions. In contrast, what Spinoza finds to be clear, literal, and consistently maintained are not the doctrines

that anyone ever went to war to defend against some rival religion. Spinoza's Biblical interpretation is guided, more thoroughly than Hobbes's, by the determination to extract from it only a rationally endorsable account of true blessedness. Since blessedness does not lie in hatred and religious wars of any kind, civil or between states, Spinoza refuses to take sides on contentious theological issues. "We can grasp with certainty the intention of Scripture concerning things salutory and necessary for blessedness. So there is no reason why we should be anxious about the rest" (*TTP*, chap. 7, sec. 68.) For all his general agreement with Hobbes about the need to "prepare a straightforward history[79] of Scripture," to look into the question of how the canon was decided, the internal and other evidence on authorship of the different books of the Bible, and so on, he could well have mentioned Hobbes as among those who "hawk his own inventions as the Word of God" (*TTP*, chap. 7, sec. 1). For Hobbes's version of the trinity, for example, surely counts as his own invention.

Spinoza is skeptical of the ability of people of his time to interpret the Bible properly. For one thing they would need to know the ancient Hebrew language—and he himself tried to help them with that by publishing a Hebrew grammar. (His own diffidence in interpreting the New Testament was based, in part at least, on his insufficient grasp of New Testament Greek.) His principles of biblical criticism, in their rigor, take up but go beyond those of Hobbes. And the official Hobbesian master rule, of saying only what manifestly tends to peace, is applied with a lot more consistency by Spinoza than Hobbes himself had managed.

Hobbes of course knew perfectly well that calling the Catholic Church "the kingdom of Darknesse" was not exactly an overture of peace towards English Catholics. (He had been banished from the court-in-exile of Charles II, to whom he had earlier been

79. The sense of "history" invoked here is that in which Francis Bacon, in a passage quoted by Hume in "Of Miracles," had written "we ought to make a collection or particular history of all monsters and prodigious births" (Bacon, *Nov. Org.*, bk. 2, sec. 29). On this use of the word "history" see Anthony Quinton, *Francis Bacon* (New York: Hill and Wang, 1980), pp. 23–24.

tutor in mathematics. His antipapal sentiments were not welcome to the future monarch of the kingdom of which he was a subject.) Within a state with an established protestant religion, he was safe from real persecution, and lived to a ripe old age comfortably enough at Chatsworth and Hardwick, where he was persuaded by the Cavendish family to desist from writing any more, after *Behemoth*, about Christian commonwealths. Spinoza, fairly even-handed in his attitude to major monotheistic religions, suffered more persecution. But then, as Aubrey reports Hobbes as acknowledging,[80] he had dared more than Hobbes. He had espoused the cause not just of religious toleration, but of an essentially secular state. Like Hume after him, Spinoza outraged *all* religious believers, not just all except one sect. No wars, religious or other, would be inspired by Spinozism, but it did incur considerable hatred against its adherents. It is not easy to preach universal goodwill and humanity in a way that does not provoke hatred in those with a vested interest in preaching something less universal and more focused than that. Nor do those who preach but do not practice a gospel of goodwill to all men take at all kindly to those, like Spinoza, who publicly wonder how those who boast of their allegiance to such a gospel can "indulge daily in the bitterest hate toward one another, so that each man's faith is known more easily from the latter [his hate] than from the former [his love]" (preface to *TTP*, sec. 14). Hobbes's faith is as easily known from his hatred of "the kingdome of Darknesse" as from any love of true religion, so he does not deserve to escape Spinoza's wonder.

80. "When Spinoza's *Tractatus Theologico-Politicus* first came out, Mr. Edmund Waller sent it to my lord of Devonshire, and desired him to send him word of what Mr. Hobbes said of it. Mr. Hobbes told his lordship 'Judge not, that ye be not judged.' He told me he had outthrown him a bar's length for he durst not write so boldly." John Aubrey, *Brief Lives,* quoted by Edwin Curley in his edition of Hobbes's *Leviathan* (Indianapolis, Ind.: Hackett Publishing), p. xviii. Aubrey also reports that Hobbes himself took communion when he thought he was on his deathbed, and this fact is cited by S. A. Lloyd, in *Ideals as Interests in Hobbes's Leviathan* (Cambridge: Cambridge University Press, 1992), p. 370, n. 10, as evidence that Hobbes was a sincere believing Christian. But we should also take note of another of Aubrey's reports—that when John Selden the jurist was dying "the minister was comeing to assoile him: Mr. Hobbes happened to be there, sayd he, What, will you that have wrote like a man, now dye like a woman? So the minister was not let in." (*Aubrey's Brief Lives,* ed. Oliver Lawson Dick [London: Secker and Warburg, 1958], p. 273.)

Spinoza, but not Hobbes, engages in his critique of Bible-based religion in the avowed cause of freedom of thought and speech. The chapter heading of *TTP,* chapter 20, uses, without quotation marks, the latter part of the proclamation by Tacitus that Hume sixty years later uses as epigraph for the first two books of *A Treatise of Human Nature:* "Rara temporum felicitas, ubi sentire, que velis; & quae sentias, dicere licet." (Spinoza had quoted extensively from Tacitus in earlier chapters.)[81] Where Hobbes encourages sovereigns to censor speech and publication, and cites the permission given to Naaman to say and do whatever his infidel sovereign commands him to do, while keeping his faith "internall and invisible," Spinoza sees more clearly than Hobbes that the reason that depends, according to Hobbes, on speech needs freedom of speech for its proper nourishment.

Any use of the art or craft of reasoning in the service of a religious (or for that matter, an antireligious) faith, which coerces people into conformity, and goes to war against the infidel, is a reason-subverting perversion of reason. Any such use of it in apologetics for a militant faith is one which makes reason a slave to violence, rather than an alternative to violence. However generous and inclusive our versions of reason, we need to be on guard against such reason-undermining reasonings, however much clever craft and cunning they display. Or perhaps our best guard against them is to treat them as attempts at humor, to give such things as *Leviathan* 3 the benefit of the doubt, and laugh at it.

81. Paul Russell has drawn attention to the significance of Hume's choice of this quotation in "Epigrams, Pantheists, and Free Thought in Hume's *Treatise:* A Study in Esoteric Communication," *Journal of the History of Ideas* 54: 659–73.

Appendix II:
Two Instructive Failures of Trust

In lecture 2 trust was taken to be involved in many intentional actions, and in our practices of holding agents and agencies to account. Since trust given to placeholders in a cooperative social scheme is appropriately given only to the extent that the scheme itself is well designed, one sort of failure of trust, namely the failure of the trusted persons to do what they were counted on to do, is often as much due to the faults or breakdown of a cooperative scheme as to any character fault in individuals. I shall retell two real-life tales of such complex failures, one recent, one from the early seventeenth century.[82]

First Tale: In July of 1993 a United Nations peacekeeping force entered the Drin hospital, near Fojnica, Bosnia, and found that the two hundred patients, mostly handicapped children (from all parts of the former Yugoslavia), had been abandoned by their medical care givers. They had been left to themselves for three days. One, Edin Lisnjic, aged two, died of dehydration; four others were in critical condition, and most were thirsty, hungry, and filthy, their bodies, beds, and living quarters smeared with excrement. Brigadier-General Vere Hayes, leading the United Nations group, is reported to have said "it's

82. I retold the first tale in "The Possibility of Sustaining Trust," in *Norms, Values, and Society. Vienna Circle Institute Yearbook 1994*, ed. Herlinde Pauer-Studer (Dordrecht: Kluwer Academic Publishers, 1994), pp. 245–59. I retold the second in a contribution to a symposium on trust at New College, Oxford, in April 1994, organized by Elizabeth Frazer, and in the Selfridge Lecture at Lehigh University, March 1995.

monstrous." (My information comes from a *New York Times* front-page story of July 20, 1993.)

I take this British officer to have made a moral judgment, and a very strong one, when he proclaimed that what the United Nations troops found was "monstrous." It was not simply the stench and the filth, which may have been as great when floods receded that year from towns and homes along the Mississippi; it was the human performance which was judged to have sunk to inhuman or "monstrous" depths. But whose performance exactly? The medical workers who abandoned their duties in the hospital were ordered to do so by a Croatian military doctor, Bogomir Barbic, who supposedly defended his order by saying that the advancing Muslim forces would have taken the medical workers captive had they found them in the hospital. The Muslim forces had not advanced to the hospital when the United Nations arrived on the scene, but there were signs that the Croatian forces had been there, indeed had partied on vodka and slivovitz left in the doctors' quarters, while the children went untended. Monstrous behavior could perhaps be attributed to these revelers, but it would seem a bit harsh to say that either the civilian medical workers, who obeyed a military order, or the military doctor who gave the order, supposedly to conserve scarce medical workers in battlefield conditions, acted monstrously, even if we query their judgment of what was permissible or best. Still, there surely was something monstrous about the entire situation. J. S. Mill wrote, "Few hurts which human beings can sustain are greater, and none wound more, than when that on which they habitually and with full assurance relied fails them in the hour of need."[83] Our understandably extreme moral judgment, in this case, seems to be directed not primarily at particular delinquent individuals, as at the situation in which they found themselves, a situation which has a very complex human causal history.

Part of what is monstrous is that the victims were especially

83. John Stuart Mill, *Utilitarianism*, chap. 5, in *Mill's Ethical Writings*, ed. J. B. Schneewind, 1st ed. (New York: Collier Books, 1965).

vulnerable, and entrusted, by parents or state agencies, to the expert care of the very ones who in effect concurred in a decision that their lives were expendable, not worth trying to save in battlefield conditions. The aspect of the Drin Hospital tragedy that is of particular interest for my concern with trust is the contribution to our reaction to what happened there that is made by our awareness of the special responsibilities taken on by the trusted health-care workers, and the habit of reliance of the patients. If the health-care workers did wrong, was their main wrong the letting down of those who had come to expect care from them? To die of dehydration after abandonment is probably no worse a fate, subjectively speaking, than to die when one's village is bombarded. But, to improve on Rousseau, the ill will of those from whom we expected goodwill outrages us more than the ill will of our avowed enemies, even when those enemies were till recently our neighbors. As sympathizing spectators, we are enraged on those children's behalf, and perhaps also enraged at the local military "defenders," on the hospital staff's behalf, since they had to trust the judgment of the military about the gravity of the threat to their own lives, and so to their ability to render any medical service to anyone. A whole network of dependencies were involved, going out from Drin to the whole of Bosnia, to the whole of what was Yugoslavia, beyond it to Europe and the United Nations. Many lettings down occurred, and are still occurring.

What is of some poignancy about the story of the Drin hospital patients is that they did not seem to lose trust in whoever turned up in the role of care giver. They apparently bore no grudge against the soldiers who appeared then disappeared when they discovered the liquor supplies. They showed instant trust and appreciation of the United Nations soldiers' efforts to clean up, and to give them water and food. David Hume noted that we feel stronger sympathy, if indeed this *is* sympathy, with the person who is unaware or not fully aware of the injury he has suffered or the danger that he is in. (His example is the person murdered in his sleep, or the infant prince who is captured by his enemies: he writes "he is more worthy of compassion the

less sensible he is of his miserable condition" [*T*, 371].) It takes the slumbering, infants, or the mentally handicapped, not to come to distrust those who are injuring them, and to give trust to the new fillers of roles whose former fillers have proved untrustworthy. And we pity those not alert enough to lose trust when trust is abused, because such alertness protects those who have it from avoidable repetition of injuries already suffered at the hands of people in positions of trust, and is continuous with the more general capacity to resent and remember wrongs.

Our extreme reaction to cases like this one of the Drin hospital is as much one of frustration and despair as indignation at any individuals. For until we can locate particular points, in the interlocking chains of command involved, where wrong decisions were made, or where impossibly difficult choices were imposed on decision makers, choices that a better-designed chain of command would have avoided or made less difficult, and until we can say whose responsibility it was and is to improve the design of the decision-making structure, our normal informal methods of holding individuals accountable seem to fail us. Everyone had some excuse for what they did, yet the outcome was inexcusable.

Second Tale: The complexity of our institutions, and their degree of robustness in extreme conditions such as civil war, depend upon informal habits and customs as well as officially designed institutional procedures. The case of Francis Bacon's fall from a position of the highest public trust shows how what some habitually rely on, and feel let down by when they fail, are questionable practices such as bribing or "lobbying" powerful officials.

Bacon held the position of lord chancellor, head of the Courts of Equity, under James I. These courts had a special responsibility to protect the potential victims of abuse of trust in the special case of legal trusts. The office of chancellor included the guardianship of minors who were the king's tenants. Hume in his *History of England* retells Fitzstephen's story of how, when Becket was chancellor, Henry II on one occasion playfully forced Becket to give his fine winter coat to a beggar,

as if beggars too were the chancellor's responsibility. The lord chancellor was the guardian of equity, and the protector of those seen to be in special danger of becoming victims of inequity. Until the Judicature Acts of 1873 and 1875, the Courts of Equity in England functioned to supplement and correct the administration of justice as it took place in the other courts. To be lord chancellor, then, was to be given a position of extraordinarily great public trust, within the complex network of the English judicial institutions.

Francis Bacon was accused of corruption and impeached, fined forty thousand pounds, and imprisoned in the Tower for a short while (at the King's pleasure). He had accepted lavish gifts from some of those whose cases he was to rule on, then often ruled against them. He could be seen either as the victim of his disappointed would-be bribers, who incited the commons to initiate impeachment proceedings against him, or as a corrupt judge getting his just deserts. James I soon released him from the tower, remitted his fine, and gave him a royal pension of 1,800 pounds a year, a fairly lavish pension given the value of the pound at the time, and as Hume writes, Bacon's literary merit was such that his "enormous abuse" of his office as chancellor, in openly accepting gifts from suitors in chancery, has been "forgotten or overlooked by posterity."[84] Hume refers to Bacon's "guilt or weakness" and sees it to lie in "intemperate desire of preferment," "prodigality," and "indulgence to servants," along with lack of that "strength of mind" needed in public officials, but not needed so much in literary pursuits. Writers, especially philosophers, are not entrusted with much, nor likely to be offered bribes, and certainly are not entrusted, as Bacon had been, with the special protection of minors and those who saw their interests as insufficiently protected by the rest of the law. The chancellor was a kind of ombudsman, the Court of Chancery a court of last appeal. If the protector of the weak was himself in the protection racket, inviting lavish gifts to support him in the style of hospitality for which he was

84. David Hume, *History of England,* chap. 49, discussing the events of the year 1621.

renowned, then where could the weak turn? *Quis enim custodiet custodes?*

Yet, as Hume emphasizes, it was not Bacon's acceptance of gifts which brought him down, it was the fact that these gifts failed to work, as bribes. "It is pretended that, notwithstanding this enormous abuse, he had still, in the seat of justice, preserved the integrity of a judge, and had given just decrees against those very persons from whom he had received the wages of iniquity."[85] The intervention of commons, lords, and king was not so much in the name of the relatively powerless whom the chancellor was supposed to be protecting, as of the indignant rich whose bribes had failed to be effective. F. M. Maitland, discussing the history of the English courts of equity, says that, early on, "one of the commonest of all reasons that complainants will give for coming to the Chancery is that they are poor while their adversaries are rich and influential. However this sort of thing cannot well be permitted. The law courts will not have it, and parliament will not have it . . . and so the Chancellor is warned off the field of common law."[86] Maitland is here speaking of the curtailing of the chancery's powers in the fourteenth century, but the same sort of resentment by the rich and influential of the chancellor's proper championing of causes other than their own was clearly still at work three centuries later. It was the *appearance* of corruption, masking his judicial "integrity," that was Bacon's mistake. Still, he fared better than the twentieth-century Colombian and Italian judges whose incorruptibility in a corrupt environment brought their assassination. The system is perceived to fail not just when the officers of the law are untrustworthy, but, it seems, also when the usual methods to turn an official's untrustworthiness to the pressurer's advantage no longer work, when treacherous "integrity" is inconveniently displayed; then complaints flood in to other powers in that delicate balance of power between chief executive, legislature, and the various courts.

85. Ibid.
86. F. W. Maitland, *Equity: A Course of Lectures,* revised by John Brunyate (Cambridge: Cambridge University Press, 1947), p. 6.

The smart acceptor of bribes accepts favors that are not so easy to trace. Indeed, when one thinks of Francis Bacon, openly receiving lavish gifts, and not being influenced by them in his judgments, one wonders if he must not really have been innocent of the charge of bribery. A guilty person would surely have taken more precautions to cover his crimes. Bacon writes to King James, about a year and a half after his impeachment, begging for a pension, so that he who desires "to live to study may not be driven to study to live," reminding the monarch of his past services and their past friendship, and of the supposed fact that "of those offenses wherewith I was charged, there was not one that had special relation to your Majesty or any of your particular commandments." The position he had held was court appointed, yet he does not see himself to have failed specifically the king. More than that, he tells the king that "both houses of parliament will love their justice the better if it end not in my ruin. For I have often been told, by many of my Lords, as it were excusing the severity of the Sentence, that they knew they left me in good Hands."[87] Bacon speaks of "a kind of Fraternity between Great Men that are, and those that have been, being but the several Tenses of one Verb," as if gently reminding the king of the precariousness of office for all "Great Men," the lack of protection they all share against malicious or false accusation. He refers to his own downfall as a "Calamity," one that gives him the privilege of making his petition. It certainly is not the letter of a repentant offender, rather that of a man resigned to the ebb and flow of favor and fortune, and the need for powerful patrons. In his position as "prostrate and castdown servant," he reminds the king of the king's past "most gracious speeches of affection and trust, which I feed on to this day." Not, one would have thought, the words of someone who has abused that trust. As Bacon writes, any offense against any of the king's subjects is in a sense an offense against the king and the king's peace, but he clearly does not see himself to have

87. This letter can be found in *Baconiana, or Certain Genuine Remains of Sir Francis Bacon* (London: Richard Chiswell, at the Rose and Crown in St. Paul's Churchyard, 1679), pp. 45–53.

offended against the king's special charges, whose welfare was entrusted to the chancellor—heirs who were minors, the especially vulnerable, those not sufficiently protected by the normal procedures of the common law.

Bacon offended the wealthy gift givers whose gifts he had not refused, and against whom he had nevertheless ruled. He was, in office, in a position where he was entrusted by the king to look after the interests of the vulnerable, yet also, as it turned out, trusted by the less vulnerable would-be influence-peddlers to give a *quid pro quo*. Perhaps he, in accepting their gifts, trusted them not to be intending to bribe? In the climate of trust/distrust of officials that seems to have existed at that time, that would have been a very naive construal. Bacon writes that "I may be frail, and partake of the abuses of the Times," but "For the Bribery and Gifts wherewith I am charged, when the Books of Hearts shall be opened, I hope I shall not be found to have a corrupt Heart, in a depraved habit of taking Rewards to pervert Justice." The customs of the times included gift giving, where the gifts were not intended as free gifts. It is a delicate matter to judge when partaking in that perhaps "abusive" practice slides into corruption and bribery. But the case of Bacon nicely illustrates the complexity of a climate of trust, the difficulty of meeting the trust of some without disappointing the trust or at least the expectations of others, and the role that institutional design and historical precedent play in creating and maintaining such sometimes treacherous climates of trust.

Appendix III:
Two Cases of Less
Than Adequately
Philosophical Anger

In lecture 3 moral reflection was optimistically taken to have the capacity not merely to judge some actions and reactions better than others, but to influence which occur, perhaps even to invent new possibilities of action and reaction where all the already available forms are found to be wanting. The expression of anger that various people display, and that various cultures condone or encourage, was taken as one case where moral reflection on the anger that gets expressed in retaliatory strikes, themselves engendering more of the same, can lead to a more benign form of anger at injury or insult, a form which is content to inflict on the culprit nothing worse than the discomfort of contrition and the humbling experience of begging for pardon. Two philosophers who gave us interesting discussions of the variety of ways in which anger gets expressed, and of the possibilities of mitigating its violence and its self-replicating power, were Spinoza and Hume. Yet instructive episodes in their lives vividly illustrate how one can see and approve of the better and milder form of anger, yet indulge in the worse and more violent. Both of the episodes I shall present are instances of that special case of anger, moral indignation. It is especially important that this form of anger not take a cruel form, nor a form that invites return indignation, since it purports to be an emotion that defends morality, the morality that itself

condemns cruelty and endless mutual retaliation. The last thing it should do is set up its own additional version of cruelty and self-replicating retaliation.[88]

In 1672 Spinoza was living in the Hague. He had been sympathetic to the republican cause in the Netherlands, opposing the monarchists. The de Witt brothers, John and Cornelius, were leaders of the republican party. Cornelius was imprisoned in the Hague on a charge of conspiring against the Prince of Orange, and John had been forced to resign from public office when an unpopular war against France and England broke out, a war for which he was blamed. While John was visiting his brother Cornelius in prison, an angry mob broke in to the prison, and brutally murdered both brothers, tore their corpses to pieces, and hung the mangled remains from a post for all to see. Spinoza, when he heard the news, wept and then raged against the "low barbarians" who were responsible for the murders. He made a placard of denunciation and wanted immediately to rush out and place it near the scene of the crime. His landlord foresaw that if he did that, he would invite the same fate as the de Witt brothers, at the hands of the incensed mob, and so locked him in the house until he had cooled down and the mob's frenzy had also passed. We may admire Spinoza's thwarted willingness to die a martyr's death, to protest what he saw as a dreadful crime, but by his own version of morality, he should not have got so worked up. He should have considered the chain of causes that led up to the mob's action, seen the whole affair *sub specie aeternitatis,* and kept his cool. He tells us at the end of book 2 of the *Ethics* that acceptance of his account of the human will, and its place in a deterministic causal order, will contribute to the improvement of social life, because, if we accept it, we will "hate no one, disesteem no one, be angry at no one, envy no one."[89] But he himself was only human, and

88. I discussed this danger in "Moralism and Cruelty," *Ethics* 103 (April 1993): 436–57. Reprinted in *Moral Prejudices: Essays on Ethics* (Cambridge, Mass.: Harvard University Press, 1994).

89. This and subsequent quotations from Spinoza's *Ethics* use the translation by Edwin Curley.

apparently did briefly feel hatred and anger for the angry mur-
derers of the de Witt brothers.[90]

David Hume, who during his life acquired a reputation for
extreme good humor, and who valued that as a character trait,
is also recorded to have once lost his cool in a rather spectacular
manner. In his case the provocation was not a murderous
assault on political figures whom he admired, but an assault on
his own character. He had escorted Jean-Jacques Rousseau to
England early in 1766, to escape persecution in Europe, and
had arranged for Rousseau to have a place to live, and a pension
from the king. Rousseau, who spoke no English, began to feel
uneasy in England and to suspect that he was being treated as a
figure of fun in the press. His suspicions were in fact correct,
but the man he charged with masterminding the press cam-
paign of ridicule was not the main culprit, Horace Walpole, but
his own benefactor, David Hume. He wrote Hume a series of
very nasty letters, accusing him of being a traitor and a false
friend, of having brought him to England merely in order to
torment and dishonor him, and he declared that he could not
accept the royal pension, since it was the traitor Hume who had
procured it for him. After initial disbelief and puzzlement,
Hume eventually became angry, and dashed off letters to his
friend the Baron d'Holbach in Paris, calling poor paranoiac
Rousseau a "monster" and "the blackest and most atrocious vil-
lain that ever disgraced human nature." He knew that Rousseau
was writing his memoirs *(The Confessions),* so had reason to
believe that he was about to make his charges in print. So
Hume composed a vindication of his conduct against
Rousseau's charges, his *Concise and Genuine Account of the Dis-
pute between Mr. Hume and Mr. Rousseau.* Close friends begged
him not to publish it, tried to persuade him that it would be
unworthy of his own good and humane nature to hit back at

90. Henry E. Allison, in *Benedict de Spinoza, an Introduction* (New Haven, Conn.:
Yale University Press, 1987), relates this episode in Spinoza's life. It is Leibniz, who vis-
ited Spinoza shortly after this event, to whom we are indebted for a record of what
Spinoza told him about it.

the pathetic Rousseau, but well-placed French friends, themselves implicated in the affair, encouraged him to publish, and he did so in October 1766, in French, then a month later in English. His anger at Rousseau's ingratitude and wild insults lasted long enough to carry him into print. Having done it, he resolved never to publish another word on the subject, and he kept that resolve. Did he regret his public response to Rousseau? His reason for writing and publishing the *Concise Account,* as given at the time, was that although he had not replied to any of fifty writers who had attacked his philosophical views, attacks on his character were different: those he felt he must answer. "This is a different case: Imputations are here thrown on my Morals and my Conduct." Later judges of his morals and conduct have on the whole found that, innocent though he was of the charges that Rousseau made, his conduct in response to those charges may have somewhat blotted his moral copybook, showing him to be not quite the saint that some of his admirers took him to be. Should one care so much about one's reputation that one makes such a fuss to vindicate it? What did Hume's version of enlightened morality itself say about that? Did he, in expressing his anger against Rousseau in the way that he did, offend as much against his own version of enlightened living as Spinoza did, in ever getting angry at all?

Hume does not, like Spinoza, believe that anger is never in place. They both agree that to fail to show any self-assertiveness, any inclination to protest injury, insult, or the violation of one's rights, can be what Hume terms "proof of weakness or imbecility" (*T,* 605). Proper pride, for Hume, is a virtue, so letting oneself be trampled on is a vice. Spinoza (in *TTP,* chap. 7, sec. 33) says that Jeremiah's and Christ's teaching to submit to injuries, to turn the other cheek,

> is appropriate only in places where justice is neglected and in times of oppression, but not in a good state. Indeed in a good state, where justice is defended, everyone is bound, if he wants to be thought just, to exact a penalty for injuries from a judge (see Leviticus 5:1), not for the sake of vengeance (see Leviticus 19:17–18), but with the intention of defending

justice and the laws of one's native land, so that the evil should not profit by being evil.[91]

To defend one's reputation, when one comes under undeserved attack, could therefore, by both Spinoza's and Hume's version of ethics, be perfectly in order, indeed for Spinoza a duty. And for Hume, but not Spinoza, becoming angry when one is undeservedly attacked need not be unreasonable. He speaks of the less "reasonable" man's anger when justly accused, found guilty, and punished (*T*, 350). That leaves a place for the more reasonable anger of the person who is unfairly accused of some wrongdoing, and perhaps unfairly subjected to the punishment of loss of good name. Were Rousseau to spread around Europe his accusation against Hume—"You brought me to England, ostensibly to procure a haven for me, but actually to dishonor me"—were he to spread abroad his charge that Hume was a calumniator and "false perfidious friend," then indeed Hume would be in the position of one who is falsely accused, and has his reputation undeservedly blackened. That he should *feel* anger is perfectly understandable. That his anger is a reasonable person's anger, we would probably grant. But that his anger should be expressed in the way it was expressed, namely in pre-emptive defense in a self-justificatory publication, is not so obviously approvable, given Hume's own version of the morally admirable person.

What then would a person with proper pride, with "a due sense of his own merit," do to stand up for himself or herself in a situation like Hume's? Rousseau's charge against Hume was made fairly publicly, although not until much later were any charges made in print. A purely private letter of protest might therefore seem insufficient. But then, as Hume knew, poor Rousseau did actually believe the charges he was making. Hume wrote, at the time, to Davenport, the Englishman who had provided a country retreat for Rousseau, and was having a really tough time as host: "I am really sorry for him. . . . if I

91. Spinoza translations in appendix 1 are by Curley, from *A Spinoza Reader.*

may venture to give my advice it is that you continue the
charitable work you have begun till he be shut up altogether in
Bedlam."[92] So what Hume had to respond to was, by his own
admission, a sincere but false public accusation from a pitiable
paranoiac. What does a properly proud and properly humane
person do in such circumstances? Presumably, trust that others
can see, as clearly as he himself did, his accuser's pitiable state,
and see if not the falseness, at least the improbability of the
charges being made. This is the way Hume's close friends urged
him to see the matter, but the advice of his more famous
learned friends, d'Holbach and d'Alembert, themselves not
uninvolved in the whole affair, prevailed with Hume over the
wiser advice of his intimate friends. It was, after all, his reputa-
tion with the learned world, the world who read even if they
also ridiculed Rousseau, that Hume cared about (and his *Con-
cise Account* appeared in French before it did in English). He
could not face the prospect of going down in recorded intellec-
tual history as guilty of calumny and false friendship. So instead
he has gone down in that history as having been a touch over-
sensitive, of having erred on the side of prickly pride, rather
than on the side of "imbecile" good nature.

In his *Treatise* account of anger's link with hatred, Hume
notes that not only knowing and deliberate injuries from others
tend to make us hate them and be angry with them, but *any*
injury coming from them, even if we know that they are guilt-
less of *mens rea*, a wicked mind. If someone is the cause of real
suffering to us, then even if we really know that he is not to be
blamed (the case Hume considers is that where the other did
not intend to make us suffer), we still tend to hate him and be
angry about the injury. "When we receive harm from any per-
son, we are apt to imagine him criminal, and tis with extreme
difficulty that we allow of his justice and innocence" (*T*, 351).

92. An account of all these events, and excerpts from the letters written during
them, are to be found in Ernest Campbell Mossner's *Life of David Hume* (Oxford:
Clarendon Press, 1950), chap. 35. For a more detailed account, including the text of
Hume's *Concise Account*, see Thomas Edward Ritchie, *An Account of the Life and Writ-
ings of David Hume* (London: T. Cadel and W. Davies, 1807; reprinted, Bristol:
Thoemmes, 1990).

Hume thinks that such natural anger will be brief, and not give rise to "lasting enmity." His own anger at Rousseau, who did not *intend* to make a false charge, but who did so, thereby hurting Hume and threatening him with lasting injury to his reputation, was only of a few weeks' duration. But that may have been too long, since it was long enough for him to react in a way that *did* cause "lasting enmity," on Rousseau's part. Hume may have forgiven Rousseau, but there is evidence that Rousseau never forgave Hume.[93] (After all, he came out of the whole thing looking plain ridiculous, which, to a properly proud person, is much worse than looking a little over defensive. He was ridiculed much more after his quarrel with Hume, than before it.)

Rousseau was Hume's beneficiary, and Hume knew very well that it is easier for benefactors to come to love their beneficiaries, than vice versa. Persons of proper pride do not like being the recipients of others' charity, and find it difficult to feel heartfelt gratitude. Hume writes: "tis impossible to do good to others, from whatever motive, without feeling some touches of kindness and good-will towards 'em" (*T,* 384). Whatever Hume's motive for escorting Rousseau to England, whether to please Madame de Boufflers, or to "have" the famous Rousseau in his charge, he did come to be fond of him, during the journey. (He reported finding him "a nice little man.") But Rousseau was in a less fortunate situation. He hated being beholden to anyone, and was unsure of why Hume was helping him. Hume was a huge man, not a little one, and had a disconcerting habit of staring at the person he was talking to, a habit that totally unnerved Rousseau. (He reported, "The external features and demeanour of *le bon David* denote a good man; but where, Great God, did this good man get those eyes with which he transfixes his friends?") Little Rousseau, in his purple fur-trimmed skirts and "sharp black eyes," more shifting and

93. Rousseau refers, at the end of his *Confessions,* to being "delivered over" to Hume by his supposed friends in Paris, whom he accuses of merely wanting to control him more successfully. And in his *Rousseau, Judge of Jean-Jacques: Dialogues,* he mulls over Hume's impetuous charges to d'Holbach, that he, Rousseau, was a monster and guilty of ingratitude. Clearly he continued to brood over Hume's countercharges.

nervous than Hume's bland pale blue eyes, was an eccentric figure, and Hume, before the quarrel, had diagnosed him as having a sensibility which rose "to a pitch beyond what I have seen any Example of. . . . He is like a man who were stript not only of his Cloaths but of his skin." Hume also surmised that, to a person of Rousseau's psychology, "his greater benefactor, being the person who most hurts his pride, becomes the principal object of his animosity." Given these prophetic insights into Rousseau's tortured soul, Hume might be expected to have understood how Rousseau was driven to make the charges he did, and then philosophically have written them off. This he failed to do, as most of us fail, when really provoked by some insult to our character that we see as wholly undeserved, even when we know that it comes from a mentally unbalanced person.

Another incident from Spinoza's life shows how, even if one feels one must publicly stand up for one's good name and one's rights, there are ways of doing so in a calm and dignified manner. After Spinoza's expulsion from the Jewish community in Amsterdam, his right to inherit as eldest son from his father's estate was denied, when it went to his half sister, on the grounds that, as a disgraced person, he had forfeited his right. He went to court, won the case, then relinquished his inheritance to his sister after all, and lived in poverty. This action, as far as we know, was not done in anger, but rather in a calm determination to establish his rights. But if he knew that he was going to renounce the inheritance anyway, was there a good reason to publicly prove his sister in the wrong? The money she would have received, as hers by right, had Spinoza lost the lawsuit, she in the end received as a gift from him. Was it so that she would have a debt of gratitude that he bothered going to law? Or did he see himself as having a duty to assert his rights? We do not know, but we might judge this act of self-assertion by Spinoza to be as dubious, by his own standards, as Hume's was by his. It may not have been done in passing anger, like Hume's, but it may nevertheless have been regrettable, and for

all we know, eventually regretted. Calm and dignity are not enough.

Spinoza devotes part of part 3 of his *Ethics* to the responses we are likely to make when we think we are hated by others. After anathema was formally pronounced upon him, he could not but feel hated by the Jewish community in Amsterdam, and by his family, as part of that community.[94] By his own version of human psychology, that community was bound to hate him for rejecting the religious beliefs they had taught him, since they would perceive themselves to be injured by a defection from a fairly prominent family. And what was he bound to feel, once rejected and disowned? According to his own theory, "He who imagines he is hated by someone, and believes he has given the other no cause for hate, will hate the other in return" (*Ethics,* pt. 3, pr. 40). Could he believe he had given the Jewish community no sufficient cause to hate him? He had defended himself against the charge of being contemptuous of the Mosaic law, but not against the charge of rejecting the doctrine that the Jews were the chosen people. He had defended his beliefs, but not denied their unorthodoxy. So he must, in a sense, have understood his synagogue's outrage at his views. In a scholium to the above quoted proposition Spinoza adds that "If he imagines he has given just cause for this hatred, he will be affected with shame. But this rarely happens." It did not happen in his own case. As he left Amsterdam, driven out by the Jewish community (who invoked a municipal statute drafted by Grotius), he is reported to have said, "my departure will be more innocent than was the exodus of the early Hebrews from Egypt. Although my subsistence is no better secured than was theirs, I take nothing away from anybody, and whatever injustice may be done to me, I can boast that people have nothing to reproach me with."

But of course a total break with family must be painful, for

94. The curse pronounced on him by the Amsterdam synagogue included the phrase "Let the wrath and indignation of the Lord surround him and smoke forever on his head."

both sides. "If someone begins to hate a thing he has loved, so
that the love is completely destroyed, then (from an equal
cause) he will have a greater hate for it than if he had never
loved it." (*Ethics,* pt. 3, pr. 38). And as for those who are hated,
in such circumstances, Spinoza says that "he who imagines one
he loves to be affected with hate towards him will be tormented
by love and hate together. For insofar as he imagines that the
one he loves hates him, he is determined to hate that one in
return. But, by hypothesis, he nevertheless loves him. So he will
be tormented by love and hate together" (*Ethics,* pt. 3, pr. 40,
cor. 1). This ambivalence, a mixture of the desire to return evil
for evil, and a reluctance to really harm a loved person, may
have been what got expressed in Spinoza's quixotic act of tak-
ing what he saw as his by right with one hand, and giving it
back with the other. And after all, he wanted to be able to say
that he had taken nothing away from anybody, when he left
Amsterdam.

Both Spinoza and Hume drew for us a portrait of the wise
person, giving details of what passions such a one would and
would not feel. Although both of them were determinists, and
believed that our reactions and actions are always in principle
predictable responses, part of a chain of causes, they both also
thought that there were ways of managing our circumstances so
that the more destructive, violent, and enmity-prolonging
responses would be avoided. It was therefore worthwhile for
the moral philosopher to set up "a model of human nature,
which we may look to" (Spinoza, preface to *Ethics,* pt. 4).
Hume's version of the person with desirable character traits is
such a model, as is the person Spinoza described in the *Ethics,*
the one who avoids all hatred, scorn, anger, and envy; who
returns love for hatred; whose wisdom is a meditation on life,
not death; who prefers living in a republic, according to com-
mon decision or public reason, to living in solitude obeying
only himself; who acts honestly not deceptively; who feels no
remorse and no pity (since these emotions merely increase the
total wretchedness, without increasing anyone's power).
Hume's model of the admirable person is a little less demand-

ing. It makes a few more concessions to passions that are "inherent in our very frame and constitution" (*T,* 605). So where Spinoza excludes all anger, Hume believes that it is sometimes in place, as long as it is "reasonable" and expressed without cruelty, a vice which is "detestable," so likely to rouse hatred and further anger at the cruel person. As for remorse, he sees that as a kind of malice and anger against oneself, and he is almost as negative about it as is Spinoza. Hume sees "those penances which men inflict on themselves for their past sins and failings" as "irregular appetites for evil," arising from a perceived contrast between what one thinks one in some sense deserves to suffer, and one's present ease, when one has got away with one's crime. "When a criminal reflects on the punishment he deserves, the idea of it is magnified by a comparison with his present ease and satisfaction; which forces him, in a manner, to seek uneasiness" (*T,* 376–77).[95] Hume does not want to encourage unnecessary humility, any more than Spinoza wants to encourage remorse. In *Enquiry Concerning the Principles of Morals* he demotes humility to a vice, especially when it motivates penance. So we may be left a little puzzled by what exactly Hume thinks is the appropriate reaction of a person to her own perceived faults of character. If humility would simply add to her faults (perhaps because of its tendency to "sour the temper"), yet if finding a vice in oneself just is the same as having cause for humility, then it seems there can be no appropriate response to faults in one's own character. Hume's views here are a bit unstable, as indeed were Spinoza's before him. Having ruled remorse out, as an emotion that a wise or "free" person will never feel, however she has acted in the past,

95. Hume thinks this influence of what he calls "the principle of comparison" works against the morally preferable principle of sympathy. It is "comparison" that also explains malice and envy. Yet Hume did not deny a place for disapprobation of one's own vices and vicious acts, and saw disapprobation as very closely linked with hatred, and so with anger. "Any quality of mind [is] virtuous, which causes love or pride; any one vicious, which causes hatred or humility" (*T,* 575). Humility, for Hume, is not analyzed as self-hatred, but simply as an enervating low estimation for oneself, leading to sympathy with others' distaste for one. It *need* not motivate one to any penances. He actually discusses this Christian virtue, humility, very little in the *Treatise,* since he is more interested there in pride.

Spinoza goes on to concede that, given that we are mostly *not* wise and free, repentance and humility may be the lesser evils. "Since men must sin, they ought rather sin in that direction [humility and repentance, rather than unbiased pride and shamelessness]. If weak-minded men were all equally proud, ashamed of nothing, and afraid of nothing, how could they be united, or restrained by any bonds? The mob is terrifying, if unafraid" (*Ethics,* pt. 4, pr. 54, schol.)

Hume too may be able to concede that, given that we live among those who fall far short of the ideal of the model person, and that we fall far short ourselves, there may be a place for a restricted form and expression of humility, even of noncruel anger against oneself. He does in any case regard "modesty," a due recognition of one's limitations, as a companion virtue to due pride, a recognition of one's strengths. Modesty need not be enervating and depressing to the spirits, in the way that Hume takes humility to be, and could motivate constructive plans to push back these limits, rather than negative penance. When such plans are wise, they will be realistic, utilizing such strengths as one knows oneself already to have, and, of course, they will have to avoid being souring to the temper.

These two cases of philosophers with wise accounts of the causes and possible correction of human anger who themselves failed to show the corrected reactions that they recommended when they themselves were put in the circumstances in which anger is natural can be seen to confirm their own shared view that there is little point in condemning something as a vice unless one can also describe a feasible way to make it really possible and not too difficult for people to avoid that vice. They had not managed to "change their circumstances," individual and social, in the ways that would have allowed Spinoza to be resigned to the behavior of the monarchist mob, or Hume to shrug off Rousseau's charges. We can perhaps think that we can easily imagine alternative scenarios where Spinoza weeps but does not rage at the news of the murder of the de Witts, where Hume is hurt but not angry at Rousseau's predictable (and in

fact predicted) ingratitude. But if, like Spinoza and Hume, we believe that human reactions are part of a deterministic order, we will admit that our alternative scenarios would have to be enlarged to include alternative social and historical settings for these individual displays of anger, or else alternative social and historical scenarios in which the occasions of their anger were averted—where, say, Rousseau had learned English so was not so isolated and alienated in his English place of refuge, or the prison guards in the Hague had kept the angry mob from breaking in. But such imaginings are fairly idle, since so much else would have to have been different for any of these particular factors to have been different.

What the views of both Spinoza and Hume allow is that the chain of causes has in fact worked out so that the human power of social invention has put in place, available to individuals, action-possibilities that avert some of the worst of the workings of anger and other destructive human passions. The invention of legally protected rights, and the procedures of going to court to demand one's legal rights, including those that the law of libel protects, makes it possible for individuals to defend themselves against some threats and attacks without resort to revenge in kind when they or their reputations are attacked. Of course such legal reaction is not without its own risk of revenge in kind. As Hume pointed out, lawyers have an interest in prolonging disputes, creating a courtroom version of "perpetual wrangling" (*E*, 257). The Supreme Court is a necessary social device for finally settling legal quarrels. We have not invented any satisfactory alternative to the life-risking indignation at injury to the public good that Spinoza displayed at the assassination of the de Witt brothers and the insult to the republican cause which that constituted. The only more philosophical recourse the righteously indignant republican can take is either to campaign to strengthen the insulted cause, or to do what Spinoza himself went on to do, write a work defending the republican ideal, and pointing out the dangers of monarchies and near monarchies, such as his own country. In chapters 6

and 7 of his unfinished *Political Treatise*, the last of his writings, he examines monarchy and the difficulties in the way of instituting and preserving limited monarchies that avoid tyranny. He had earlier, in *TTP*, published before the assassination of the de Witts, diagnosed the tyrannical tendencies of monarchical government, and shown how "a people have often succeeded in changing tyrants, but never in abolishing tyranny or substituting another form of government for monarchy" (*TTP*, chap. 18).[96] In the *Political Treatise* he repeats this diagnosis, in more detail. So he did try to make a reflective philosophical response to the barbaric blow to the republican cause inflicted by the murderous monarchist mob of 1672. In the *Political Treatise* he mentions the house of Orange only in passing, as a recently overthrown republic. (William of Orange, later of England, was declared *Statholder* after the insurrection of 1672.)

This civilized form of response to a perceived wrong, namely a reasoned publication defending the cause that had been injured, might be thought to have been precisely the form Hume opted for, when he defended his own attacked character in the *Concise Account*. Why then have I treated it as an unreasonable expression of quite reasonable outrage? Primarily because of the very personal nature of the events it made public and because of the pathetic condition of the exposed ingrate. But it is never easy to judge just how personal is too personal to make public, just how pathetic a wrongdoer has to be to make pity, rather than indignation, the appropriate response. And Hume did have the excuse of having reason to fear that Rousseau was about to include his version of events in his *Confessions*, a work that outdoes almost any other work by a philosopher, even St. Augustine, in making public the personal and private. Resorting to publication is not always a well-judged and fully reflected form of response, or even of attempted self-understanding. It is interesting that when

96. This passage is not included in Curley's excerpts from *TTP* in *A Spinoza Reader*. This translation is by Samuel Shirley, p. 277 of Baruch Spinoza, *Tractatus Theologico-Politicus*, trans. Samuel Shirley (Leiden: E. J. Brill, 1989).

Hume next composed anything autobiographical, it was "My Own Life," written a few months before his death. It far out-does the *Concise Account* in conciseness, and, in accordance with Hume's resolve to have done with that topic, does not mention the quarrel with Rousseau. Indeed it includes the amazing statement "though most men in any wise eminent, have found reason to complain of calumny, I was never touched, or even attacked by her baleful tooth." Can he have not only forgiven but forgotten?

Bibliography

Alanen, Lilli, Sara Heinämaa, and Thomas Wallgren, eds. 1996. *Commonality and Particularity in Ethics*. New York: Macmillan.

Allison, Henry E. 1987. *Benedict de Spinoza, an Introduction*. New Haven, Conn.: Yale University Press.

Anscombe, G. E. M. 1981. "Promising and Justice." In *Collected Philosophical Papers*. Oxford: Basil Blackwell.

———. 1957. *Intention*. Ithaca, N.Y.: Cornell University Press.

Aubrey, John. 1958. *Aubrey's Brief Lives*. Ed. Oliver Lawson Dick. London: Secker and Warburg.

Bacon, Francis. 1679. *Baconiana, or Certain Genuine Remains of Sir Francis Bacon*. London: Richard Chiswell, at the Rose and Crown in St. Paul's Churchyard.

Baier, Annette C. 1996. "Doing Things with Others." In *Commonality and Particularity in Ethics*, ed. Alanen, Heinämaa, and Wallgren. New York: Macmillan.

———. 1995. "Moral Sentiments and the Difference They Make." In *The Supplementary Volume of the Aristotelian Society*, ed. Jonathan Wolff, pp. 15–30.

———. 1994a. "How to Get to Know One's Own Mind: Some Simple Ways." In *Philosophy in Mind*, ed. Michaelis Michael and John O'Leary-Hawthorne. Dordrecht: Kluwer Academic Publishers, pp. 65–82.

———. 1994b. *Moral Prejudices: Essays on Ethics*. Cambridge, Mass.: Harvard University Press.

———. 1994c. "The Possibility of Sustaining Trust." In *Norms, Values, and Society*, ed. Herlinde Pauer-Studer. Dordrecht: Kluwer Academic Publishers, pp. 245–59.

———. 1994d. *Tanner Lectures on Trust*. Vol. 13 of *Tanner Lectures on Human Values*. Salt Lake City, Utah: University of Utah Press. Reprinted in Baier 1994b.

———. 1993. "Moralism and Cruelty." *Ethics* 103: 436–57. Reprinted in Baier 1994b.

———. 1992. "The Virtues of Resident Alienation." *Nomos* 34, *Virtue*. New York: New York University Press, pp. 291–308.

———. 1990a. "Natural Virtues and Natural Vices." *Social Philosophy and Policy* 8, no. 1, *Ethics, Politics, and Human Nature* (autumn): 24–34.

———. 1990b. "A Naturalist View of Persons." *Proceedings and Addresses of the American Philosophical Association* 65, no. 3 (November 1991): 5–17. Reprinted in paperback edition of Baier 1994b.

———. 1985. *Postures of the Mind: Essays on Mind and Morals.* Minneapolis, Minn.: University of Minnesota Press; New York: Methuen.

———. 1981. "Cartesian Persons." *Philosophia* 10, nos. 3–4. Reprinted in Baier 1985.

———. 1979. "Mind and Change of Mind." *Midwest Studies in Philosophy, Metaphysics* 4: 157–76. Reprinted in Baier 1985.

———. 1976a. "Intention, Practical Knowledge, and Representation." In *Action Theory,* ed. Brand and Walton. Dordrecht: D. Reidel Publishing Company, pp. 27–43.

———. 1976b. "Mixing Memory and Desire." *American Philosophical Quarterly* 13, no. 3: 213–20. Reprinted in Baier 1985.

———. 1972. "Ways and Means." *Canadian Journal of Philosophy* 1, no. 3: 275–93.

Becker, Lawrence C. and Charlotte B. Becker. 1992. *Encyclopedia of Ethics.* Vol. 2. New York: Garland Publishers.

Berkeley, George. 1910. *A Treatise Concerning the Principles of Human Knowledge.* Chicago, Ill.: Open Court Publishing Company.

Brand, Myles and D. Walton, eds. 1976. *Action Theory.* Dordrecht: D. Reidel Publishing Company.

Brandom, Robert B. 1994. *Making It Explicit: Reasoning, Representing, and Discursive Commitment.* Cambridge, Mass.: Harvard University Press.

Bratman, Michael. 1992. "Shared Cooperative Activity." *Philosophical Review* 101.

———. 1990. "What is Intention." In *Intentions in Communication,* ed. Cohen, Morgan, and Pollack. Cambridge, Mass.: MIT Press.

———. 1987. *Intention, Plans, and Practical Reason.* Cambridge, Mass.: Harvard University Press.

Burnyeat, Myles. 1995. "Anger and Revenge," talk given to the University of Pittsburgh Philosophy Department intrafaculty colloquium.

Butler, Joseph. 1897. *The Works of Joseph Butler.* Ed. W. E. Gladstone. Oxford: The Clarendon Press.

Clarendon. See Hyde.

Cohen, Philip R., Jerry Morgan, and Martha E. Pollack, eds. 1990. *Intentions in Communication.* Cambridge, Mass.: MIT Press.

Collins, Arthur. 1987. *The Nature of Mental Things.* Notre Dame, Ind.: University of Notre Dame Press.

Darwall, Stephen. 1995. *The British Moralists and the Internal Ought 1640–1740.* New York: Cambridge University Press.

De Salvo, Louise. 1995. *Conceived with Malice: Literature as Revenge.* New York: Penguin Books.

Descartes, Rene. 1985. *The Philosophical Writings of Descartes.* 2 vols. Ed. John Cottingham, Robert Stoothoff, and Dugald Murdoch. New York: Cambridge University Press.

———. 1912. *Oeuvres de Descartes.* 12 vols. Charles Adam and Paul Tannery (1897–1913). Reprinted Paris: J. Vrin, 1957 and 1986.

Elster, Jon. 1989. *The Cement of Society.* New York: Cambridge University Press.

Foot, Philippa. 1994. "Does Moral Subjectivism Rest on a Mistake?" *Oxford Journal of Legal Studies* 15, no. 1: 1–14.

Gilbert, Margaret. 1992. *On Social Facts.* Princeton, N.J.: Princeton University Press.

Hobbes, Thomas. 1994. *Leviathan.* Ed. Edwin Curley. Indianapolis, Ind.: Hackett Publishing Company.

Hume, David. 1983–85. *The History of England from the Invasion of Julius Caesar to the Revolution in 1688.* Indianapolis, Ind.: Liberty Classics.

———. 1978. *A Treatise of Human Nature.* Ed. L. A. Selby-Bigge and P. H. Nidditch. Oxford: The Clarendon Press.

———. 1975. *Enquiries.* Ed. L. A. Selby-Bigge and P. H. Nidditch. Oxford: The Clarendon Press.

Hyde, Edward (Earl of Clarendon). 1676. *A Brief Survey of the Dangerous and Pernicious Errors of Church and State in Mr. Hobbes's Book Entitled Leviathan.* Oxford, printed at the Theatre.

Kant, Immanuel. 1974. *Anthropology from a Pragmatic Point of View.* Translated, with introduction and notes, by Mary J. Gregor. The Hague: Nijhoff.

———. 1965. *Critique of Pure Reason.* Trans. Norman Kemp Smith. New York: St. Martin's Press.

———. 1934. *Religion within the Limits of Reason Alone.* Chicago: Open Court Publishing Company.

Lloyd, S. A. 1992. *Ideals as Interests in Hobbes' Leviathan.* New York: Cambridge University Press.

Locke, John. 1980. *Second Treatise of Government.* Edited with introduction by C. B. Macpherson. Indianapolis, Ind.: Hackett Publishing Company.

———. 1975. *An Essay Concerning Human Understanding.* Ed. P. H. Nidditch. Oxford: The Clarendon Press.

———. 1970. *Some Thoughts Concerning Education.* Menston, England: Scolar Press.

Magri, Tito. "Hume and Our Motivation to be Moral and Rational," unpublished manuscript.

Maitland, F. W. 1947. *Equity: A Course of Lectures.* Ed. A. H. Chaytor and W. J. Whittaker, revised by John Brunyate. Cambridge: Cambridge University Press.

Massey, Gerald. 1976. "Tom, Dick, and Harry and All the King's Men." *American Philosophical Quarterly* 13, no. 2: 89–107.

Michael, Michaelis and John O'Leary-Hawthorne, eds. 1994. *Philosophy in Mind: The Place of Philosophy in the Study of Mind. Philosophical Studies Series* 60. Dordrecht: Kluwer Academic Publishers.

Mill, John Stuart. 1965. *Mill's Ethical Writings.* Ed. Jerome B. Schneewind. New York: Collier Books.

———. 1948. *Utilitarianism.* Ed. Oskar Piest. New York: Liberal Arts Press.

Mintz, Samuel I. 1962. *The Hunting of Leviathan.* New York: Cambridge University Press.

Mossner, Ernest Campbell. 1950. *Life of David Hume.* Oxford: The Clarendon Press.

Nozick, Robert. 1981. *Philosophical Explanations.* Cambridge, Mass.: Har-

vard University Press.

Pauer-Studer, Herlinde, ed. 1994. *Norms, Values, and Society. Vienna Circle Institute Yearbook 1994.* Dordrecht: Kluwer Academic Publishers.

Quinn, Philip. 1995. "Political Liberalisms and their Exclusions of the Religious." *Proceedings and Addresses of the American Philosophical Association* 69, no. 2: 35–56.

Quinton, Anthony. 1980. *Francis Bacon.* New York: Hill and Wang.

Rawls, John. 1993. *Political Liberalism.* New York: Columbia University Press.

Ritchie, Thomas Edward. 1807. *An Account of the Life and Writings of David Hume.* London: T. Cadel and W. Davies. Reprinted, Bristol: Thoemmes, 1990.

Rousseau, Jean-Jacques. 1990. *Rousseau, Judge of Jean-Jacques: Dialogues.* Ed. Roger D. Masters and Christopher Kelly; trans. Judith R. Bush, Christopher Kelly, and Roger D. Masters. Hanover, N.H.: University Press of New England.

———. 1987. *Basic Political Writings.* Trans. and ed. Donald A. Cress. Indianapolis, Ind.: Hackett Publishing Company.

———. 1971. *Confessions.* London: Dent; New York: Dutton.

Ruetsche, Laura. 1995. "On the Verge of Collapse: Modal Interpretations of Quantum Mechanics." Ph.D. Dissertation, Department of Philosophy, University of Pittsburgh.

Russell, Paul. 1993. "Epigrams, Pantheists, and Free Thought in Hume's *Treatise:* A Study in Esoteric Communication." *Journal of the History of Ideas* 54: 659–73.

Schneewind, Jerome B. 1995. "Voluntarism and the Foundations of Ethics." *Proceedings and Addresses of the American Philosophical Association,* 69.

———. 1990. *Moral Philosophy, from Montaigne to Kant.* 2 vols. New York: Cambridge University Press.

Schwarzenbach, Sibyl A. Forthcoming. "On Civic Friendship." *Ethics.*

———. 1992. "A Political Reading of the Reproductive Soul in Aristotle." *History of Philosophy Quarterly* 9, no. 3: 243–64.

Searle, John. 1990. "Collective Intentions and Actions." In *Intentions in Communication,* ed. Cohen, Morgan, and Pollack. Cambridge, Mass.: MIT Press.

Shaftesbury, Third Earl of (Anthony Ashley Cooper). [1714]. 1900. *Characteristics of Men, Manners, Opinions, Times.* Ed. John M. Robertson. London.

Spinoza, Benedictus de. 1994. *Ethics.* In *A Spinoza Reader,* ed. Edwin Curley. Princeton, N.J.: Princeton University Press.

———. 1989. *Tractatus Theologico-Politicus.* Trans. Samuel Shirley. Leiden: E. J. Brill, 1989.

Stewart, Dugald. 1948. *The Elements of the Philosophy of the Human Mind.* New York: James Eastman and Co.

Swift, Jonathan. 1958. *Collected Poems.* Cambridge, Mass.: Harvard University Press.

———. 1896. *Gulliver's Travels.* Boston, Mass.: Houghton Mifflin Company.

Thomas, Laurence. 1992–93. "Moral Deference." *The Philosophical Forum*

24, nos. 1–3: 233–50.

Thompson, Michael. 1995. "The Representation of Life." In *Virtues and Reasons,* ed. R. Hursthouse, G. Lawrence, and W. S. Quinn. New York: Oxford University Press.

Urmson, J. O. 1950. "On Grading." *Mind* 59, no. 234: 145–69.

Wallace, R. Jay. 1994. *Responsibility and the Moral Sentiment.* Cambridge, Mass.: Harvard University Press.

Warthe, Mary Ellis. 1992. "Women Moral Philosophers." In *Encyclopedia of Ethics,* ed. Becker and Becker. New York: Garland Publishers.

The Whole Duty of Man: Necessary for All Families. 1684. London: Printed by R. Norton for Robert Pawler, at the Sign of the Bible, Chancery Lane.

Wollstonecraft, Mary. 1988. *A Vindication of the Rights of Woman, with Strictures on Political and Moral Subjects.* 2d ed. Ed. Carol H. Poston. New York: Norton.

———. 1980. *A Vindication of the Rights of Men, in a Letter to the Right Honorable Edmund Burke.* Ed. Eleanor Louise Nicholes. Facsimile ed. Delmar: Scholars Facsimiles and Reprints.

———. 1974. *Thoughts on the Education of Daughters: With Reflections on Female Conduct, in the More Important Duties of Life.* New York: Garland Publishers.

Index

abortion, 61–63, 62n
accountability, 34, 35–40, 57–58
action, 1n, 40, 41, 85
Advice on the Education of Daughters
 (Wollstonecraft), 15
Amsterdam Jewish community,
 92–93
anger, 45–47, 46n, 85–99
Anscombe, G.E.M., 33, 49
Aquinas, St. Thomas, 18
Aristotelians, 2
Aristotle, 13, 45
artifices, 38–39
Aubrey, John, 74, 74n

Bacon, Francis, 73n, 80–84
Becket, Thomas à, 80
Berkeley, George, 6–7
Biblical interpretation
 Hobbes', 66–69, 71–74
 Spinoza's, 71–73, 75
Bratman, Michael, 1n, 26
Brown, Antoinette, 31
Burke, Edmund, 15
Burnyeat, Myles, 46
Butler, Joseph, 46–47

Calvinism, 54, 54n, 70
Catholic Church, 70, 73–74
The Cement of Society (Elster),
 27n–28n
Charles II, 73–74
Christianity, 46–47, 46n, 65–69, 72
Clarendon, Edward Hyde, Earl of,
 70
Clarke, Samuel, 57, 57n
Collins, Arthur, 1n
commons of the mind, 1, 41–42, 44,
 63
community, 1, 13–14, 42

community of nature, 1
con- and prefix variants in action
 verbs, 22n
*Concise and Genuine Account of the
 Dispute between Mr. Hume
 and Mr. Rousseau* (Hume),
 87–88, 90, 92n, 98
Confessions (Rousseau), 87, 91n, 98
convention, 22, 22n
Critique of Pure Reason (Kant), 42,
 63

Descartes, René, 2–7
 account of liberty, 35–37
 in conversational pursuits as rea-
 sonings, 12, 12n
 on desires, 44
 import of negation in reasoning,
 14–15
 on recognition of reasoning in
 others, 3
 on sole authorship of reason,
 5–6, 13
 on speech employed in problem
 solving, 8
 and transubstantiation, 65
de Witt, Cornelius and John, 86–87
Discourse on Inequality (Rousseau),
 48n
*Discourse on the Method of Rightly
 Conducting One's Reason*
 (Descartes), 2, 5
Drin Hospital incident, 77–80

Elster, Jon, 27n–28n
*Enquiry Concerning Human Under-
 standing* (Hume), 39n
*Enquiry Concerning the Principles of
 Morals* (Hume), 95
Ethics (Spinoza), 86, 93–94, 95–96

in competency of others, 29–35,
31n, 32n, 37, 57
concerned with morality, 58
two instructive failures of,
77–84
trustworthiness, 33–34, 57
and accountability, 34, 37–38,
57–58

Vindication of the Rights of Men
(Wollstonecraft), 15
Vindication of the Rights of Women
(Wollstonecraft), 15

virtue, 12

*The Whole Duty of Man: Necessary for
All Families* (Hume), 54, 54n
will (Cartesian), 35–37
wit, 9–11
Wolff, Christian, 57
Wollstonecraft, Mary, 15
women, 15–16, 51n
abuse of, 52–53
equality of, 56
suffrage of, 16